THE LAND THROUGH A LENS

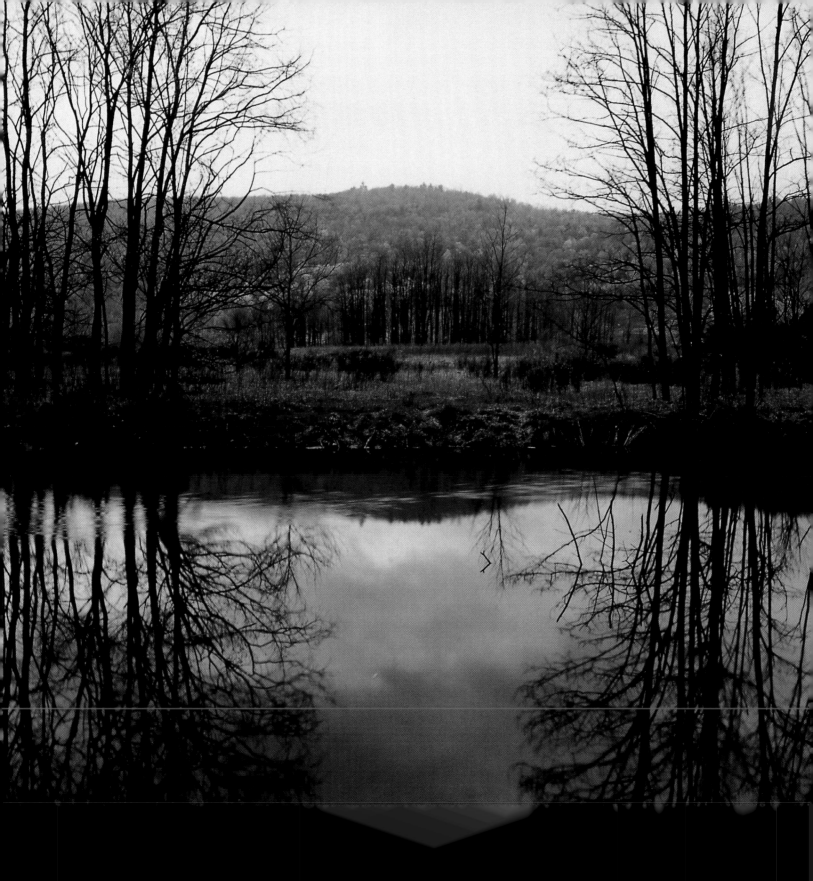

THE LAND THROUGH A LENS

Highlights from the
Smithsonian American Art Museum

Andy Grundberg

Smithsonian American Art Museum

The Land Through a Lens: Highlights from the Smithsonian American Art Museum

By Andy Grundberg

Chief, Publications: Theresa J. Slowik
Designers: Karen Siatras, Steve Bell
Editor: Timothy D. Wardell

Library of Congress Cataloging-in-Publication Data

Smithsonian American Art Museum.
 The land through a lens : highlights from the Smithsonian American Art Museum /
Andy Grundberg ; foreword by Elizabeth Broun.
 p. cm.
 Includes index.
 ISBN 0-937311-57-X (softcover)
1. Landscape photography—United States.
2. United States—Pictorial works. 3. Photograph collections—Washington (D.C.) I. Grundberg, Andy. II. Title.
 TR660.5 .S63 2003
 779'.36'074753—dc21
 2002154512

Printed and bound in Spain

First printing, 2003
1 2 3 4 5 6 7 8 9 / 08 07 06 05 04 03 02 01

© 2003 Smithsonian Institution
First published in 2003

Cover: William H. Jackson, *Grand Cañon of the Colorado* (detail), about 1880, albumen print. Smithsonian American Art Museum, Purchase from the Charles Isaacs Collection made possible in part by the Luisita L. and Franz H. Denghausen Endowment (see page 60)

Frontispiece: Joe Maloney, *East Branch, Delaware River, New York* (detail), 1979, Ektacolor print. Smithsonian American Art Museum, Gift of the Consolidated Natural Gas Company Foundation (see page 68)

The Land Through a Lens is one of five exhibitions presented as
Highlights from the Smithsonian American Art Museum,
touring the nation through 2005.

Foreword

Working in a museum, I have come to appreciate the joys of repeated encounters and easy intimacy with works of surpassing tranquility or great power. I also love the surprise of the unexpected when I see something new or challenging in another museum. Visitors here and abroad share these same experiences, encountering artworks as familiar friends in settings close to home or unanticipated discoveries in different places.

The Smithsonian American Art Museum is the nation's museum dedicated exclusively to the art and artists of the United States. The collections trace the country's story in art spanning three centuries, and its in-depth resources offer opportunities to understand that story better. While our main building undergoes extensive refurbishment, we have a great opportunity to share our finest artworks with everyone across the nation.

From 2003 through 2005, five traveling shows will feature four hundred works, including modern African American art, landscape photography, master drawings, contemporary crafts, and pre-1850 quilts. Readying this wave of ambassadors has called upon the talents and enterprising spirit of the entire staff, especially the curators, conservators, registrars, and editors. I would like to thank all who have worked so hard to make possible this ongoing initiative to share our collections during the renovation period. We are also grateful for the support of the Smithsonian Special Exhibitions Fund and numerous

supporters as well as to the several dozen American museums who will graciously host these traveling exhibitions.

Seductive beauty, promise, and myth mingle with America's history and its technological and economic progress in these landscape photographs. Although portraits were photography's first real success, a prolific record of landscape features and connected events evolved as soon as cameras and equipment could be reliably used outdoors. Whether incorporating the nineteenth-century notion of the sublime or twentieth-century theories of social documentary, each is a witness to a profound and often complex relationship to the land.

We invite you to revisit our collections as familiar friends when they are installed in the museum's beautifully restored building in Washington, a historic artwork in its own right. There you will encounter expanded spaces for exciting special exhibitions and for the permanent collection's showcasing, including the Luce Foundation Center for American Art. This open-storage facility will house five thousand paintings, sculptures, and craft and folk objects previously inaccessible to the public. A new publicly visible conservation lab will reveal the complex processes of restoring artworks, while an array of public programming and educational resources, onsite and online, will also enhance the experiences of visitors and researchers alike. We look forward to welcoming you to the new Smithsonian American Art Museum.

Elizabeth Broun
The Margaret and Terry Stent Director
Smithsonian American Art Museum

ANSEL ADAMS

1902–1984

Monolith: The Face of Half Dome, Yosemite Valley
from the portfolio *Parmelian Prints of the High Sierras*

1926–27/
printed 1927
gelatin silver print
11 7/8 x 9 7/8 in.
Smithsonian
American Art
Museum,
Musem purchase

The majesty of this photograph of California's Yosemite Valley is a recognizable signature of Adams's work, which exemplifies the aesthetic ambitions of American landscape photography throughout much of the twentieth century. The picture's clarity of description, sharpness of detail, and broad range of tones from white to black seem to demonstrate the photographer's commitment to a pure, unembroidered rendition of the scene before the lens. This is not entirely the case, however. Adams has framed the scene in a way that isolates and simplifies the mountain forms, heightening our sense of their dignity and power.

The soaring granite face of Half Dome marks a precipitous geological divide between Yosemite Valley and its High Sierra, and Adams's picture marked a crucial aesthetic turning point in his career as a landscape photographer. The photograph, he later explained, was the first in which he was able to use his considerable technical skills to capture exactly the image that was in his mind's eye at the moment of exposure. Most notably, in this case he used a red filter to darken the otherwise pale afternoon sky. This "visualization" method, as Adams called it, required exacting exposure and development of the negative and considerable skill in the printing process. Consequently, Adams personally developed and printed his work throughout his career. How he chose to print his negatives changed radically over time. This print was made soon after he took the photograph, and it clearly shows all the surface detail of the cliff, even the part in shadow.

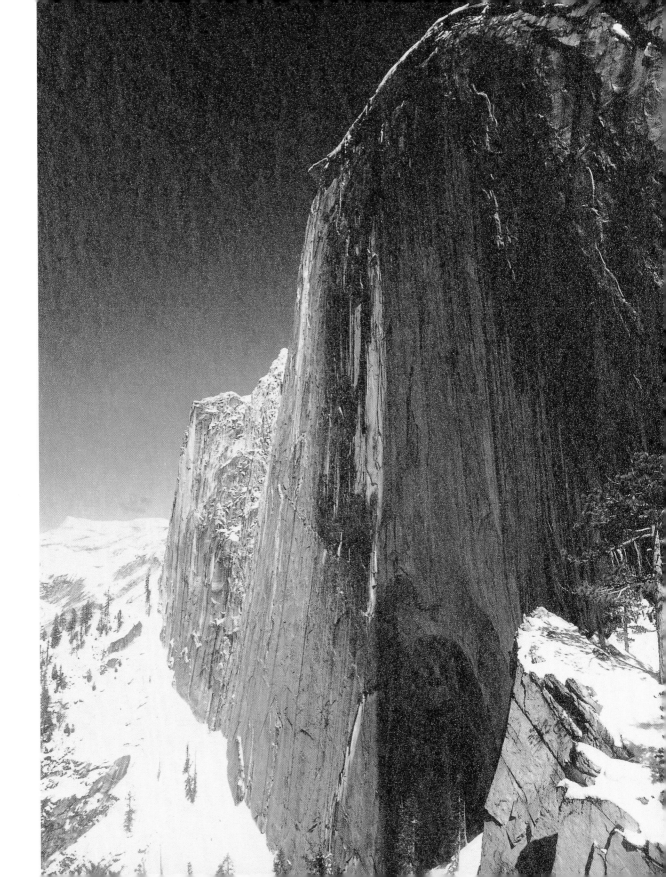

ANSEL ADAMS

1902–1984

On the Heights, Yosemite Valley

from the portfolio *Parmelian Prints of the High Sierras*

1926–27/
printed 1927
gelatin silver print
9 ⅞ x 11 ⅞ in.
Smithsonian
American Art
Museum,
Musem purchase

With his camera set up not far from where he took his picture *Monolith: The Face of Half Dome,* and on the same early spring day, Adams chose to frame this long view of Yosemite Valley with a rugged cedar tree. This foreground element seems a picturesque, almost decorative touch, except that it directs the viewer into the middle distance, where a human figure stands on the edge of a sharp ridge. The placement of this figure—she is Virginia Best, who was soon to become Adams's wife—harks back to precedents in nineteenth-century photography.

This print was included in a portfolio published in 1927 intended to promote Adams's career. Prints of this era, when Adams was just reaching artistic maturity, are often referred to as Parmelian prints because that was the term used in the title of the portfolio, *Parmelian Prints of the High Sierras* [sic]. However, "Parmelian" is a meaningless, near word that was coined by the portfolio's publisher to disguise the fact that Adams's pictures were simple photographs, made like almost all photographs on paper coated with a conventional silver gelatin emulsion.

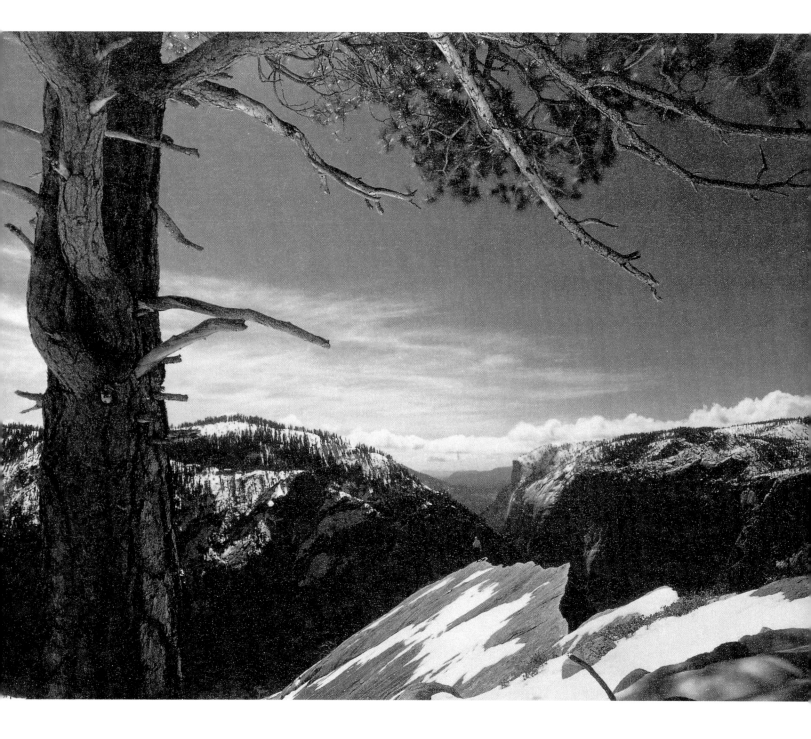

ANSEL ADAMS

1902–1984

Winter Sunrise, Sierra Nevada from Lone Pine, California

1944/printed 1978
gelatin silver print
14 ½ x 19 ⅜ in.
Smithsonian
American Art
Museum,
Gift of Jane and
Arthur K. Mason

A dramatic contrast of light and shadow, provided free of charge by an early morning sunrise, is largely responsible for making this image one of Ansel Adams's most popular photographs. The crisply etched, snowy pinnacles of the Sierra Nevada, seen from the east, loom above a band of dark, nearly black foothills. Below the foothills a sunlit line of trees defines a field in which a single horse grazes, seemingly oblivious to the magnificence of the display in the distance. The image might be understood as a photographer's parable about the endurance of natural beauty, which persists even though we may fail to pay attention to it.

As this picture attests, Adams did not work exclusively in Yosemite, nor did he always insist on showing the natural world as an uninhabited wilderness. The horse in the field tells us that the valley floor has been domesticated; Adams was there because he was documenting a community of thousands of Japanese Americans at nearby Manzanar, one of several internment camps set up by the government during World War II. Another community, the town of Lone Pine, made itself felt in the picture by inscribing the initials "LP" in the hillside on the left. This was too much human presence for Adams, who insisted on meticulously spotting out the offending white scars to make them invisible in the print.

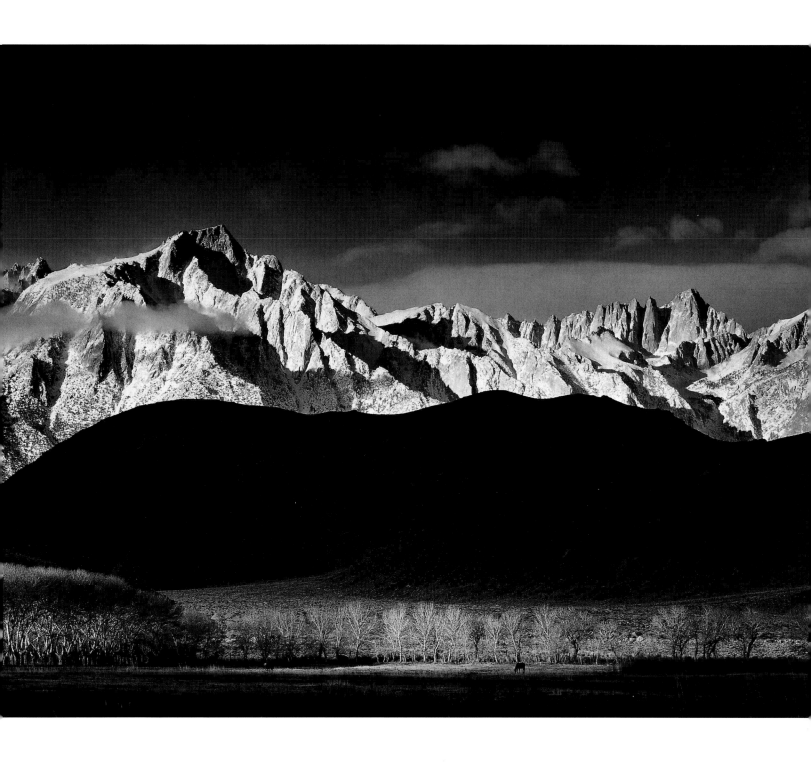

ROBERT ADAMS

born 1937

Burning Oil Sludge, Weld County, Colorado

1974
gelatin silver print
6 x 7 ⅝ in.
Smithsonian
American Art
Museum, Gift of
Virginia Zabriskie

The thick, roiling plume of black smoke that streams across this otherwise delicate and high-key picture of northern Colorado has a sinuous formal beauty, but that surely is not the whole of this image's story. The smoke also functions as a rent in the continuity of the snow-swept plain that secures the photograph's foreground and as an obstruction that blots the distant mountains and sky. These visual facts suggest that the photographer has composed the picture to heighten our sense of beauty's fragility.

Robert Adams is a leading member of a generation of landscape photographers dissatisfied with the pure, unblemished beauty depicted so well by Ansel Adams (no relation). In Robert Adams's case, his art hinges on his ability to show the natural world as simultaneously beautiful and impinged on by human ignorance and rapacity. Here, for example, the presence of an oil well in the center foreground signals that the fire is fueled by oil sludge, a byproduct of this extractive, industrial practice. But at the same time the picture is beautiful because of the fire. Whether one reads this as irony or ambivalence, there is no mistaking the sense of foreboding the photograph conveys.

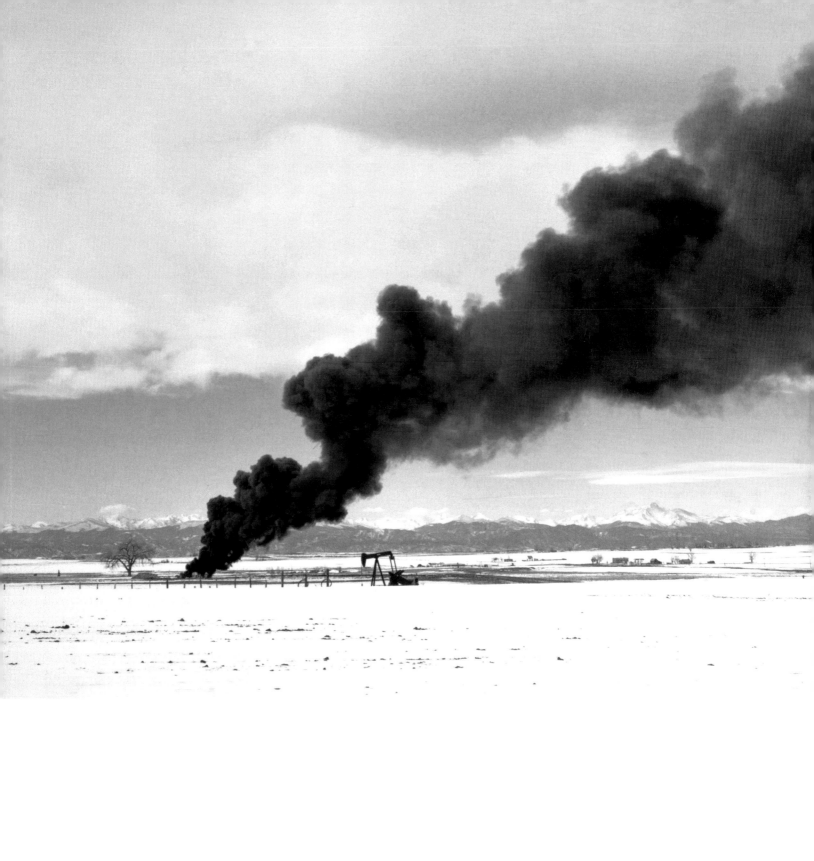

GRACE M. BALLENTINE

1881–1978

Up from the Sea

about 1940
gelatin silver print
14 x 16 ⅞ in.
Smithsonian
American Art
Museum, Gift of
Dr. Robert M.
Ballentine

Having tilted her camera to an angle of forty-five degrees, Ballentine disorients spatial perception to the extent that what are small ridges of wind-blown sand are seen as huge dunes or mountains. But a more lasting effect is the way in which the ripples of sand proceed from the print's lower right corner up and across the receding foreground, much like waves from the sea itself. This may be what Ballentine had in mind when she titled the picture *Up from the Sea*.

Ballentine is a little-known photographer associated with a movement that has almost been erased from the medium's twentieth-century history: pictorial photography. She was drawn to photography in the 1920s because she needed illustrations to project during her horticultural lectures, and she learned to make pictures in a soft, bucolic style that harked back to turn-of-the-century photographers like Gertrude Kasebier and Clarence White. Despite becoming unfashionable, pictorial photography of the sort she practiced into the 1960s had its own network of competitions, salons, and awards. Ballentine's prints won many blue ribbons from like-minded judges but seemed hopelessly out of date to her more modern contemporaries. Today we can admire them as a kind of educated folk art.

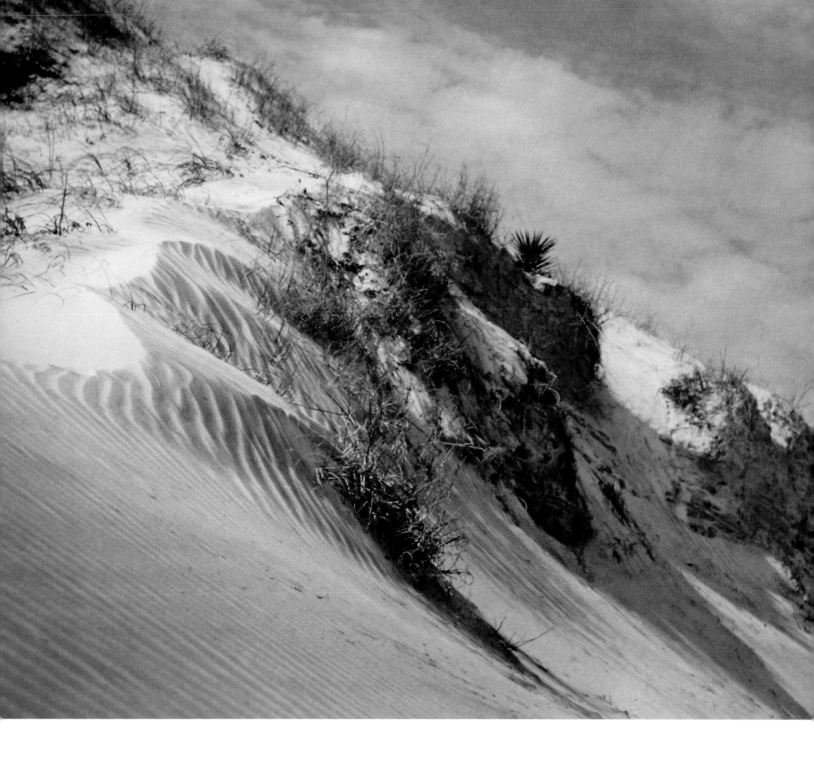

GEORGE BARKER

1844 Canada–1894 USA

The Falls in Winter

about 1888
albumen print
16 1/4 x 19 in.
Smithsonian
American Art
Museum,
Purchase from the
Charles Isaacs
Collection made
possible in part
by the Luisita L.
and Franz H.
Denghausen
Endowment

In a reversal of its accustomed role, Niagara Falls serves as the backdrop to a huge frozen dome in this technically difficult image by the accomplished photographer of the falls, George Barker. Working in the cold of winter soon after a snowstorm, Barker utilized his largest camera, which required a tripod and a sensitized glass-plate negative some 16 by 19 inches, and captured the scene down to the footprints and sled tracks on the dome itself. The source of these signs of activity is also discernable: three small figures appear just to the left of the dome, apparently watched over by two even smaller figures high on the cliff beside the falls. Barker provides an extraordinary variety of wonders from which to choose: the startling parfait of ice and snow layers that constitute the dome, the precarious bravado of the people on the falls' edge, the daring enterprise of the photographer in taking the picture, and finally the magnificent, overpowering falls itself.

Like many nineteenth-century photographers, Barker originally wanted to be a landscape painter but was sidetracked by the lure of the early daguerreotype process. He worked long enough to embrace a number of subsequent techniques, including stereo photography. His stereo views of the falls were widely distributed in the United States, Canada, and Europe. This picture is more ambitious. It was probably offered for sale at Barker's Niagara studio to tourists with substantial wallets.

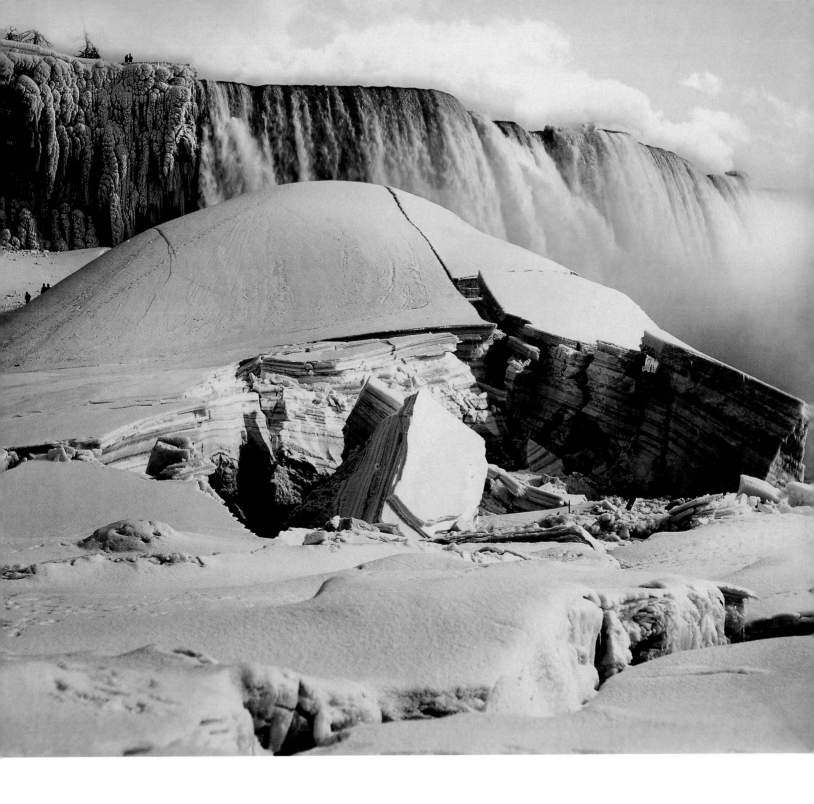

WILLIAM BELL

1830 England–1910 USA

Perched Rock, Rocker Creek, Arizona

from the Wheeler Survey

1872
albumen print
10 ¾ x 8 in.
Smithsonian
American Art
Museum,
Purchase from the
Charles Isaacs
Collection made
possible in part
by the Luisita L.
and Franz H.
Denghausen
Endowment

As direct, straightforward, and no-nonsense as a surveyor's transit, this image of an apparently isolated boulder balanced at the edge of a desert was taken not for scenic pleasure but for the information it might reveal to the trained eyes of an engineer or scientist. As a pragmatic document of the government-sponsored Wheeler Survey of 1872, which undertook to explore territory "west of the 100th Meridian" (a demarcation that runs, roughly, through Dodge City, Kansas), the photograph was in effect commissioned by the Army Corps of Engineers and the War Department. Still, one suspects that the photographer was captivated by the visual strength of the poised, bulky rock, which looks like it might have once been a triangle that fell from the sky. To ensure that viewers would grasp its enormous size, Bell included the figure of a man, crouching below the rock in the lower right-hand corner and wearing a light-colored hat.

Bell, who replaced the more experienced Timothy O'Sullivan as the Wheeler Survey's official photographer, was used to looking with dispassion at out-of-the-ordinary objects. After his service in the Civil War, he was appointed head of photography at the Army Medical Museum in Washington, D.C. There he took pictures of soldiers' gunshot wounds and surgical amputations, as well as still lifes of skulls and bones shattered by bullets. Perhaps this explains why Bell's perched rock resembles an archaeological specimen of an earlier species.

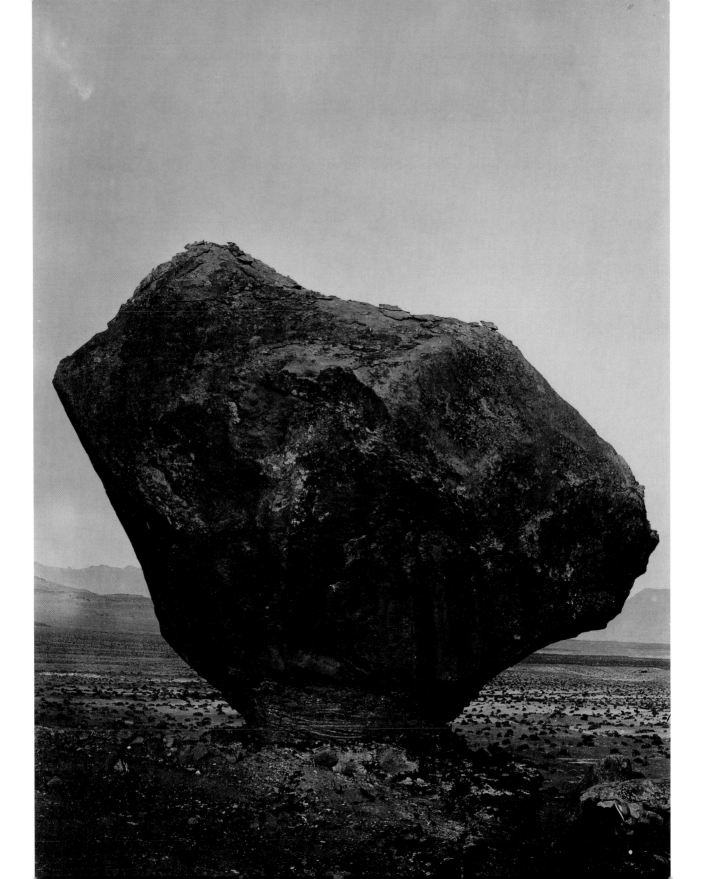

CHARLES BIERSTADT

1819 Germany–1903 USA

The Rapids, below the Suspension Bridge

about 1870

albumen print

7 x 9 ¼ in.

Smithsonian

American Art

Museum,

Purchase from the

Charles Isaacs

Collection made

possible in part

by the Luisita L.

and Franz H.

Denghausen

Endowment

Bierstadt, a brother of painter Albert Bierstadt and a competitor of George Barker in the Niagara photography trade, was downstream from the falls when he took this picture of John Augustus Roebling's elegant, two-level suspension bridge over the Niagara River. As the image makes clear, the river was no less tumultuous here than in the immediate vicinity of the falls, and one marvels that Bierstadt stood his ground so fearlessly. The bridge, of course, represents the success of American ingenuity in triumphing over the obstacles nature would throw in its path. Its geometric, rational organization is strikingly unlike the chaotic, blurred flow of water below it, and Bierstadt probably saw it as a sign of human progress.

Bierstadt may not have been able to make his point so easily as it seems at first glance, however. Like many photographs of the era, the print shows signs that more than one negative was needed to produce it. Some experts suspect he used three separate negatives—one of the bridge, one of the raging river, and one of the clouds in the sky—to achieve this result. Equally true of landscape photography as it is of landscape painting, the intentions of the image-maker often can supercede any pretense of representing reality as the eye sees it.

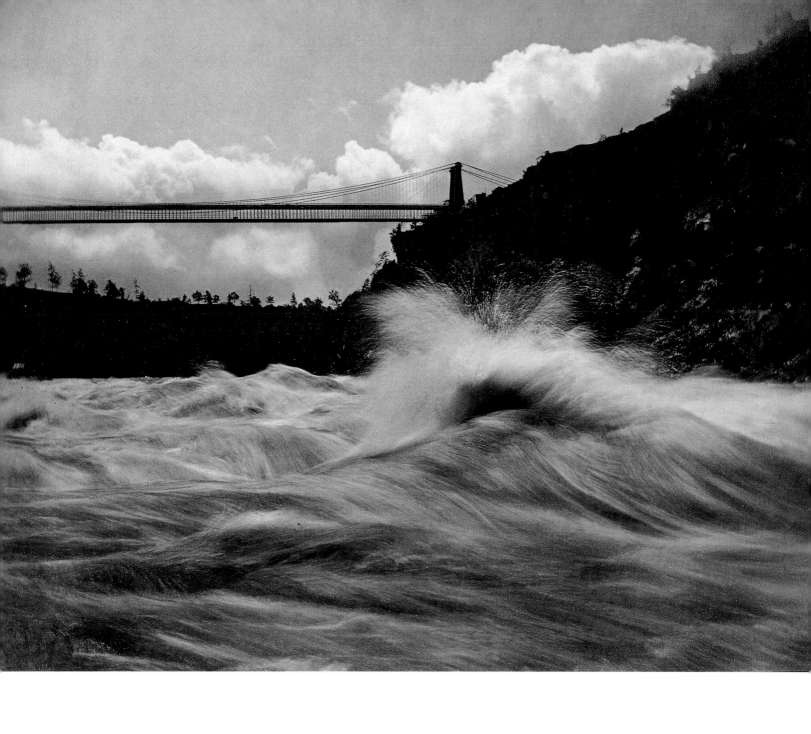

ANNE BRIGMAN

1869–1950

The Dying Cedar

1906

platinum print

9 ¼ x 6 ⅜ in.

Smithsonian
American Art
Museum,
Purchase from the
Charles Isaacs
Collection made
possible in part
by the Luisita L.
and Franz H.
Denghausen
Endowment

The draped nude female figure in Brigman's indistinct, penumbral landscape is clearly more than an indicator of the size of the tree or a sign of human presence in the American West. With her upraised arms and tilted wrist, the model mimics the cedar's twisted form and gives it a dreamy poignancy. She is, perhaps, the mythological figure of Cassandra, prophesying the tree's eventual doom.

Brigman, who lived in Oakland, California, had license to indulge in such allegorical narratives. She was a member of the Photo Secession, an affiliation of turn-of-the-century photographers who believed that photography could be an art only when it stepped away from literal description of facts. As a result, most of their pictures were carefully posed, and most were printed using hand-applied emulsions, such as platinum, that distinguished them from the prints of amateur snapshooters. This image and four others by Brigman were reproduced in 1909 by Alfred Stieglitz, the Photo Secession's leader, in his legendary journal *Camera Work*. But Stieglitz soon forsook the ideas of the Photo Secession in favor of the more modern notion of "pure" photography, and Brigman's career foundered. In the 1930s she switched her attentions to writing poetry.

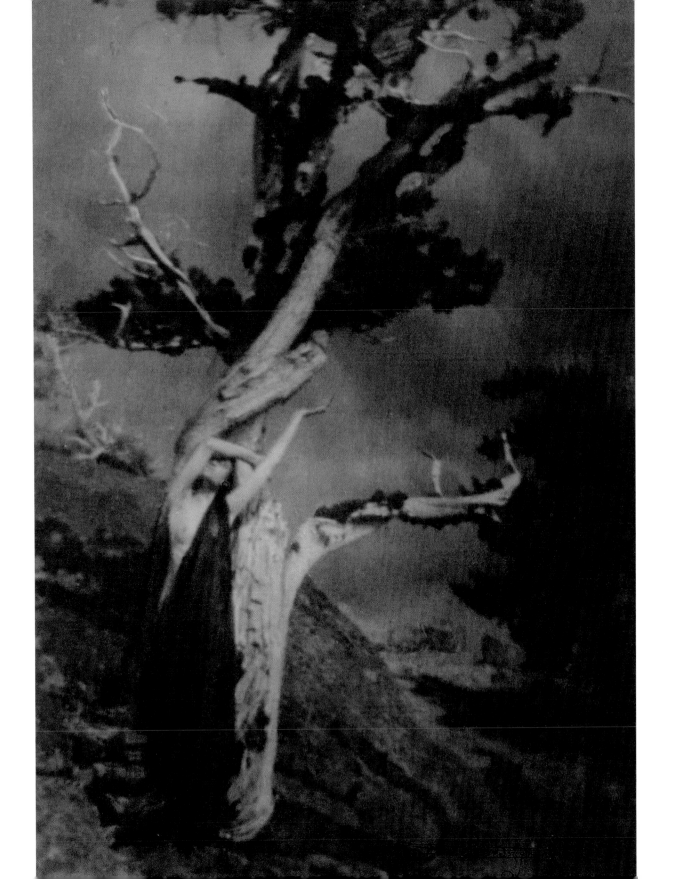

DREX BROOKS

born 1952

Sweet Medicine: Council Grounds of the Great Treaty at Horse Creek, Nebraska

1987/printed 1989
toned gelatin silver
print
14 x 20 7/8 in.
Smithsonian
American Art
Museum,
Gift of the
Consolidated
Natural Gas
Company
Foundation

In Drex Brooks's seemingly straightforward landscape from the Midwest, the strong central tree trunk (a beech, judged by its peeling appearance) and the myriad ranks of corn stalks aligned behind could stand for historical memory. On this site in 1851, thousands of Native Americans gathered to ratify a treaty that established peace among the tribes while also guaranteeing the U.S. government the right to pass through Indian lands. History, of course, has long passed by the treaty, just as in the image time has etched the tree's bark and transfigured the field beyond it.

In the late 1980s Brooks, who lives in Ogden, Utah, photographed a number of sites related to the Indian Wars for a series he called *Sweet Medicine*. Here, as in all the pictures in that series, he makes explicit the connection between landscape and history by including a text as an integral part of the image. The words of Sitting Bull resonate with irony, given that the Horse Creek treaty included a pledge by the government to protect Indian lands from further white settlement. As a result the image, which is gracefully composed but lacks any strident visual drama to distract us from its content, becomes an ironic statement of its own.

I wish all to know that I do not propose to sell any part of my country, nor will I have the whites cutting our timber along the rivers, more especially the oak. I am particularly fond of the little groves of oak trees. I love to look at them, because they endure the wintry storm and the summer's heat, and—not unlike ourselves—seem to flourish by them. —Sitting Bull (Lakota)

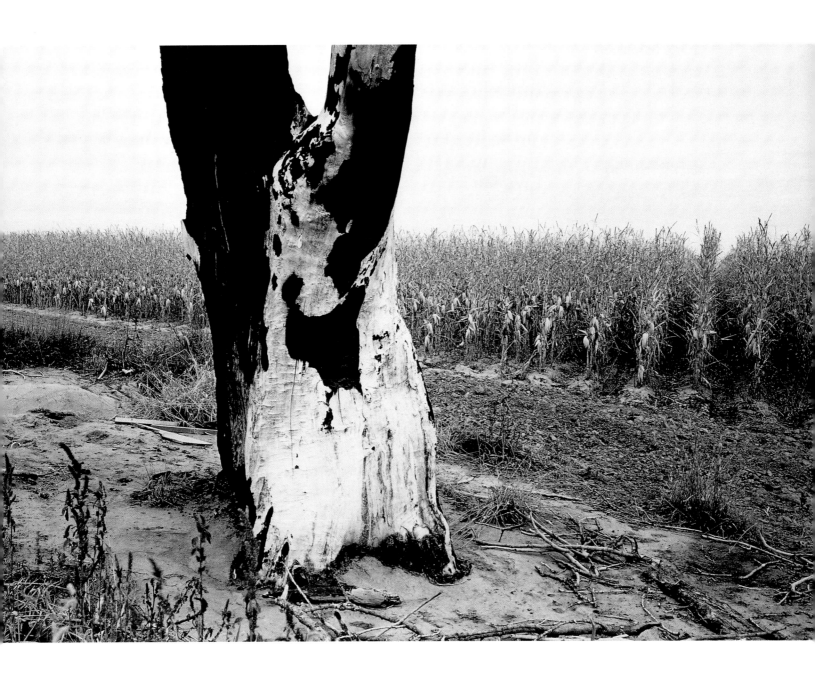

WILLIAM CHRISTENBERRY

born 1936

Red Soil and Kudzu—near Moundville, Alabama

1980/printed 1981
Type-C print
17 ³⁄₈ x 22 in.
Smithsonian
American Art
Museum, Gift of
Dr. Martha Gross

A splash of red clay jutting out of a verdant field of green vegetation—
an amalgam of prosaic pine forest and pernicious kudzu vine—defines
this picture as a product of the American South. William Christenberry,
who is known for his paintings and sculpture as well as for his photo-
graphs, has made his native Alabama the central figure in all of his
artwork. In most of his photographs, crumbling buildings or other evi-
dence of human handiwork dominate the foreground, but here nature
alone conveys the feeling of place.

By filling nearly half the frame with kudzu, Christenberry encour-
ages viewers to speculate about what its broad leaves have blanketed. Is
the renegade plant overtaking pine trees like those in the background,
or has it covered over one of the artist's favorite cabin structures, erasing
all evidence of human presence? One also might wonder why the red
clay soil lies bare and unmolested nearby. While such speculations are
destined to remain unresolved, the image dramatizes a tension between
past and present that is felt not only in nature but also in the culture
of the modern South.

WILLIAM CLIFT

born 1944

Landscape, New Mexico

from the portfolio *New Mexico*

1973

gelatin silver print

9 x 12 ¾ in.

Smithsonian
American Art
Museum,
Transfer from
the National
Endowment
for the Arts

With its endless vista dotted by dark scrubs of tumbleweed and bisected by white coursing lines that mark roads and rivers, William Clift's photograph affords all the virtues of the classic landscape genre except one: No human beings are present in the picture to survey the scene for us. Such human presence was conventional in landscape painting before photography's invention and is common in nineteenth-century photographs of the American West. In the twentieth century, photographers largely ended the practice in order to emphasize the purity of the natural world and to focus attention on the formal attributes of their pictures.

Clift, being of a later generation than Ansel Adams, has allowed signs of human alteration of the land to appear in the center of the frame. But these tracks seem insignificant compared with the deep space of the broad plain that covers three quarters of the picture and the seemingly endless rows of mountains that rise up at its top. Perhaps the rainstorm brewing in the distance will soon arrive to wash away the scars of our tenuous presence, giving this view even more magnificence.

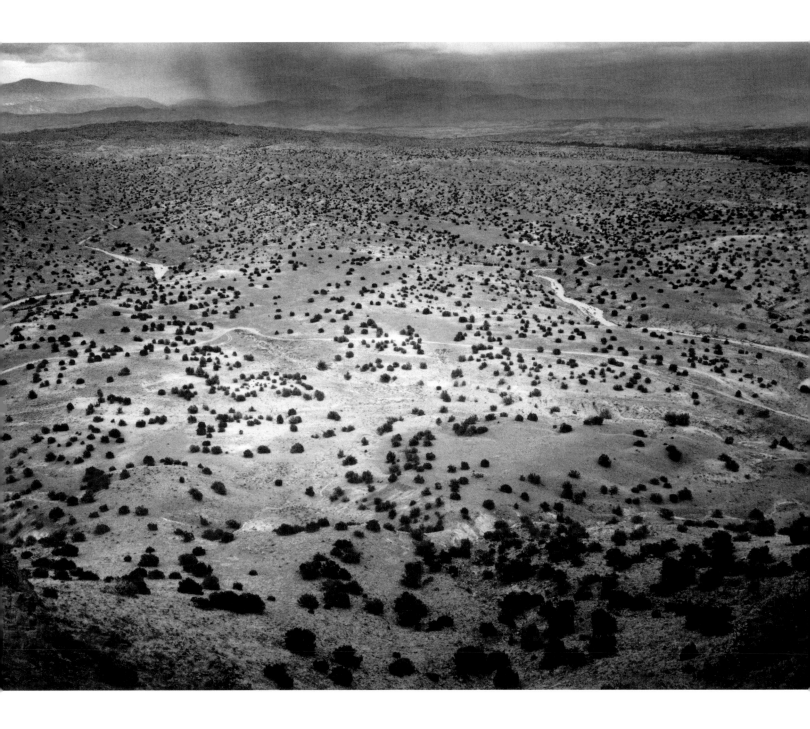

LINDA CONNOR

born 1944

Dots and Hands, Fourteen Window Ruin, Bluff, Utah

1987
gelatin silver print
8 x 10 in.
Smithsonian
American Art
Museum,
Gift of the
Consolidated
Natural Gas
Company
Foundation

Striations in sandstone rock provide this precisely rendered photograph with an element of visual intricacy, but they also are reminders of the ancient geological formation of the American West. Long after sand was turned to rock eons ago, and even long before the arrival of the first European visitors to the continent's interior, an ancient people living in the Southwest followed the vectors of the rock lines by adding rows of painted dots to the cliff surface, creating what are known as petroglyphs. They also affixed the imprint of their own hands, as if to say, "We were here." This reminder of an earlier (albeit mysterious) urge to use the Western landscape as the grounds for making art gives Linda Connor's photograph a complex resonance.

To nineteenth-century explorers of the American West, such a sight would have provoked astonishment, since they likely assumed they were the first visitors to value the notion of making pictures of their experience. For today's viewer, the feeling is something more akin to awe, mingled with humility. Connor, whose work of the past thirty years has sought to show a connection between the physical world and the world of the spirit, allows the mystery of how these petroglyphs came to be, and what they might signify, to speak for itself.

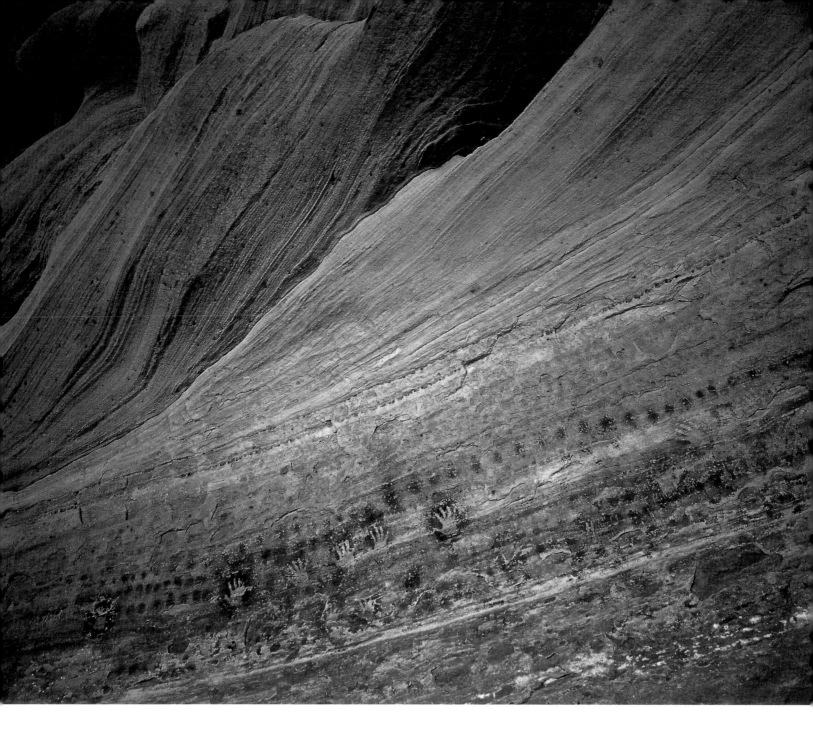

DWIGHT A. DAVIS

1852–1944

A Quiet Pool (Early Evening)

about 1905

platinum print

12 ¼ x 9 ⅜ in.

Smithsonian
American Art
Museum,
Purchase from the
Charles Isaacs
Collection made
possible in part
by the Luisita L.
and Franz H.
Denghausen
Endowment

Printed in rich, warm tones, Davis's soft-focus image of a lily-rimmed pond is as much about the beauty of the photographic print as it is about the beauty of its subject. Fittingly, this aesthetic is called pictorialism because of its emphasis on the picturesque qualities of the image. This is not to say that Davis lacked strong feelings for nature, only that for him and his pictorialist colleagues at the turn of the century the art of photography was rooted in its similarities with painting. Like the American impressionist painters who were his contemporaries, including William Merritt Chase, Childe Hassam, and Willard Metcalf, Davis sought to convey a sense of the atmosphere and light particular to a given scene rather than to describe it precisely. Here, the diffused glow of the still pond is accented by dots of light emanating from the budded lilies that protrude above the water's surface. The effect is calm and wistful.

To produce pictures with this kind of luminous quality, Davis and other pictorialists used specially made lenses that form diffuse halos of light around objects and thus obscure fine detail. They often printed on light-sensitive papers coated with platinum rather than on mass-manufactured silver-gelatin emulsions to distinguish their work from that of amateurs using the new Kodak cameras. In this regard pictorialism is allied with the Arts and Crafts movement in England and the United States, which reacted to late-nineteenth-century industrialization by promoting handmade, individually crafted objects.

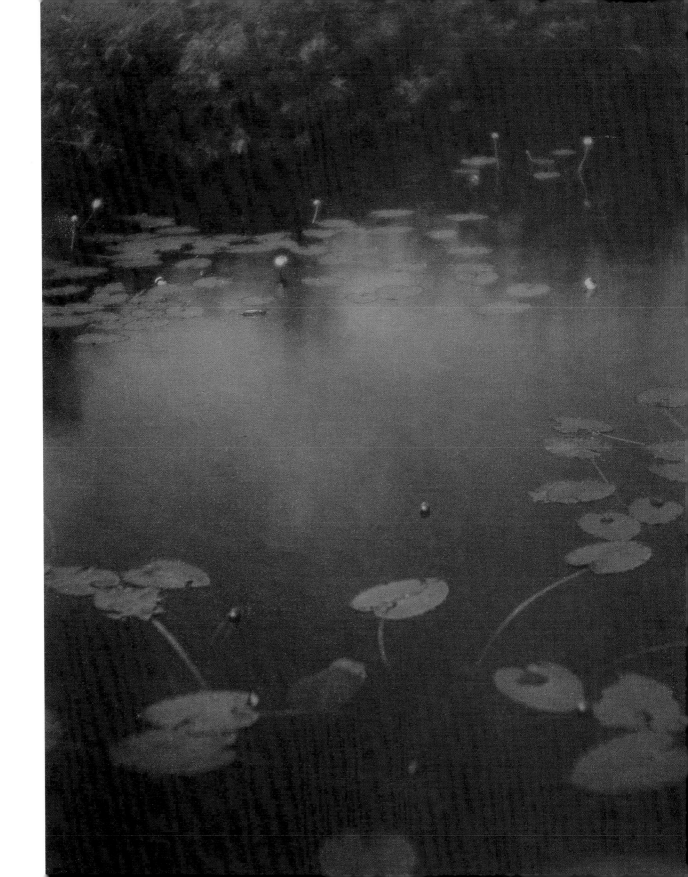

ROBERT DAWSON

born 1950

Polluted New River, Calexico, California

from the *California Toxics Project*

1989
gelatin silver print
13 ⁷⁄₈ x 17 ³⁄₄ in.
Smithsonian
American Art
Museum, Gift of the
Consolidated
Natural Gas
Company
Foundation

Puffy white shapes dot a flowing stream in this California border landscape, looking as benign and pleasant as the billowing clouds that they seem to mirror. But the title of the image dispels the notion that this is just pretty scenery. The suds in the stream are evidence of serious water pollution, and they are as much harbingers of trouble as funnel clouds on the Great Plains. The New River, which receives its pollutants from both Mexico and the United States, has been called the filthiest stream in the nation. That beauty should surprise us like this is no surprise; that beauty should rebuke us is another story.

Dawson has long looked at environmental problems in his native state of California, and particularly at issues of water use. His pictures are primarily documentary in style and are intended to serve as advocates for change. The effort to enlist landscape photographs on behalf of saving or conserving natural resources is not new. No less a photographer than Ansel Adams enlisted his photographs in the Sierra Club's fight against dam projects in the Sierra Nevada. But Dawson is part of a generation of photographers, most of whom began photographing in the 1970s, who try to capture a less exalted form of beauty in their pictures—a beauty as compromised by human interference as nature itself. The open, apparently unfinished building on the left and the line of palm trees in the picture's center are not meant to be picturesque or sublime, but merely evidence of the way things are.

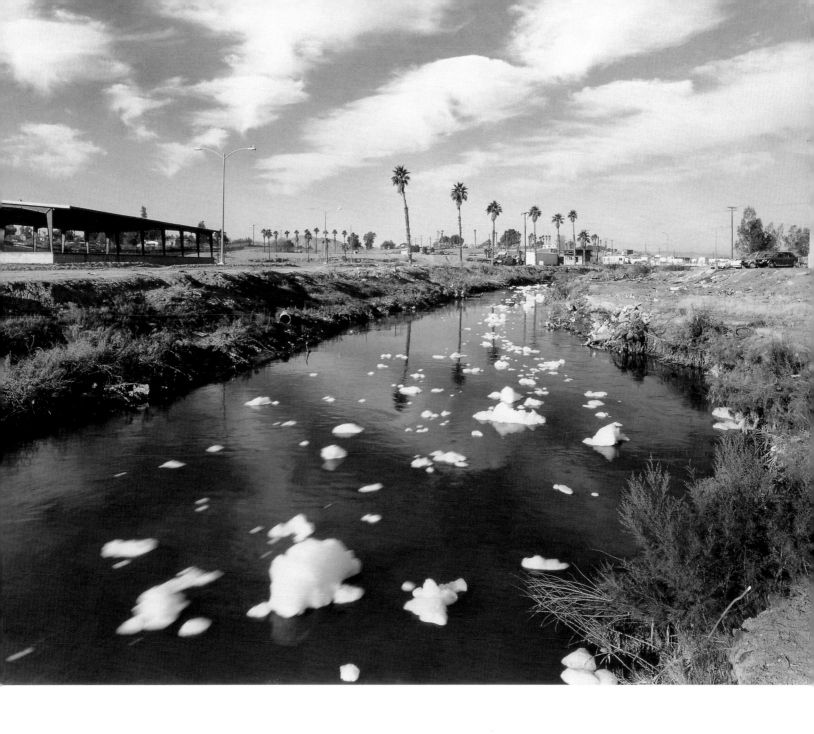

TERRY EVANS

born 1944

Konza Prairie

1982
Ektacolor print
19 x 19 in.
Smithsonian
American Art
Museum,
Gift of the
Consolidated
Natural Gas
Company
Foundation

The edenic innocence of the original American landscape is evoked in Terry Evans's aerial photograph of Kansas prairie. Working from a small plane flown at low altitudes, Evans filled the frame from edge to edge with a soft yellow-green color that varies in tone much like a black-and-white photograph. By eliminating the horizon line and all trace of the sky, she made the scene seem self-contained and self-sufficient, while also allowing viewers to read the picture simply as an array of curving, abstract forms. Only the trace of a pickup trail, traversing the upper part of the image, pulls us back to the reality that the Konza Prairie is a carefully managed preserve in the midst of miles and miles of farmland.

Evans, like a number of contemporary artists, is greatly concerned with how Americans use the land and, by virtue of using it, change its appearance. But her work acknowledges that visual harmony can be found even in places totally transformed by human intervention. In her photographs of prairie—a subject she has pursued for more than twenty-five years—she tries to find a balance between natural beauty and the beauty that the camera is capable of discovering.

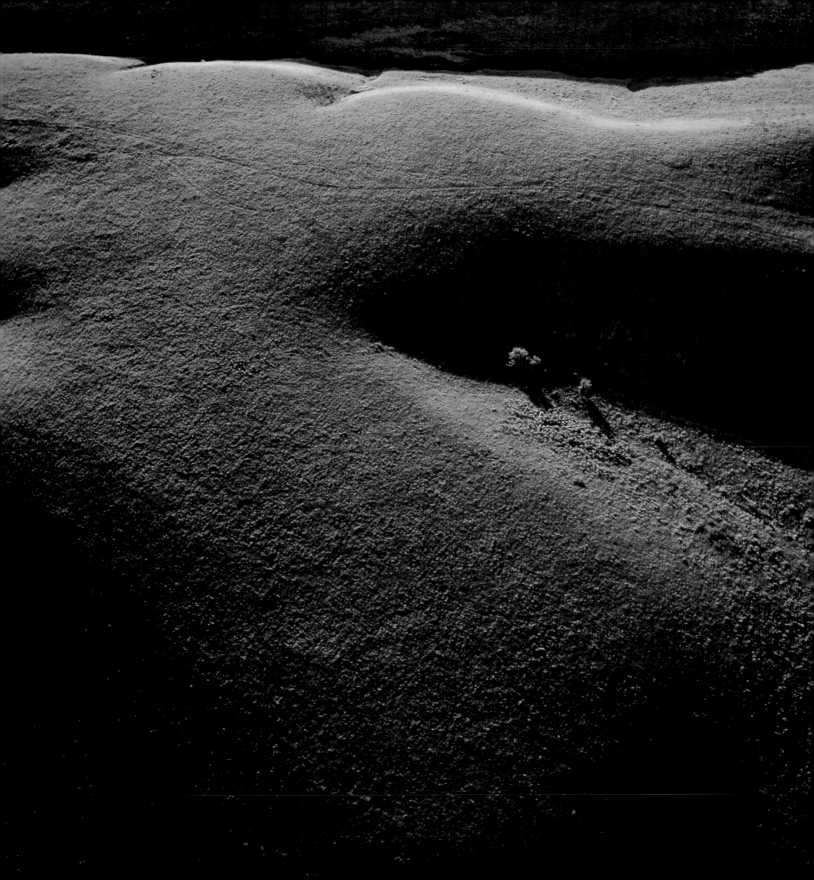

LARRY FINK

born 1941

Untitled

from the Seattle Arts Commission Photo Survey

1980
gelatin silver print
8 7/8 x 8 7/8 in.
Smithsonian
American Art
Museum, Transfer
from the National
Endowment
for the Arts

Poised at the point of falling, its trunk cut through by a lumberjack's chainsaw, this majestic redwood embodies a balance of human effort and natural beauty. Unlike pictures of logging in the Pacific Northwest taken 100 years earlier, which highlight the skill and bravery of the loggers who bring down big trees, here the photographer's intent is purposefully ambiguous. Is the photograph an indictment of a society that turns living trees into lumber for patio decks, or an acknowledgement of the forest's capacity to provide for our needs? By not taking explicit sides on the question, the photograph encourages its viewers to weigh the costs and benefits.

Fink is known primarily as a photographer of social activity, ranging from fashion shows and art openings in New York City to family gatherings and boxing matches in rural Pennsylvania. This picture is unusual because it was taken as part of a survey project sponsored by the Seattle Arts Commission and supported by the National Endowment for the Arts. Fink spent his time in Washington documenting timber operations and a lumber community on the Olympic Peninsula. Many photographers found such commissions to be a welcome way to expand their work in new directions; in spirit, at least, they worked in the tradition of the great Western exploration photographers of the 1870s.

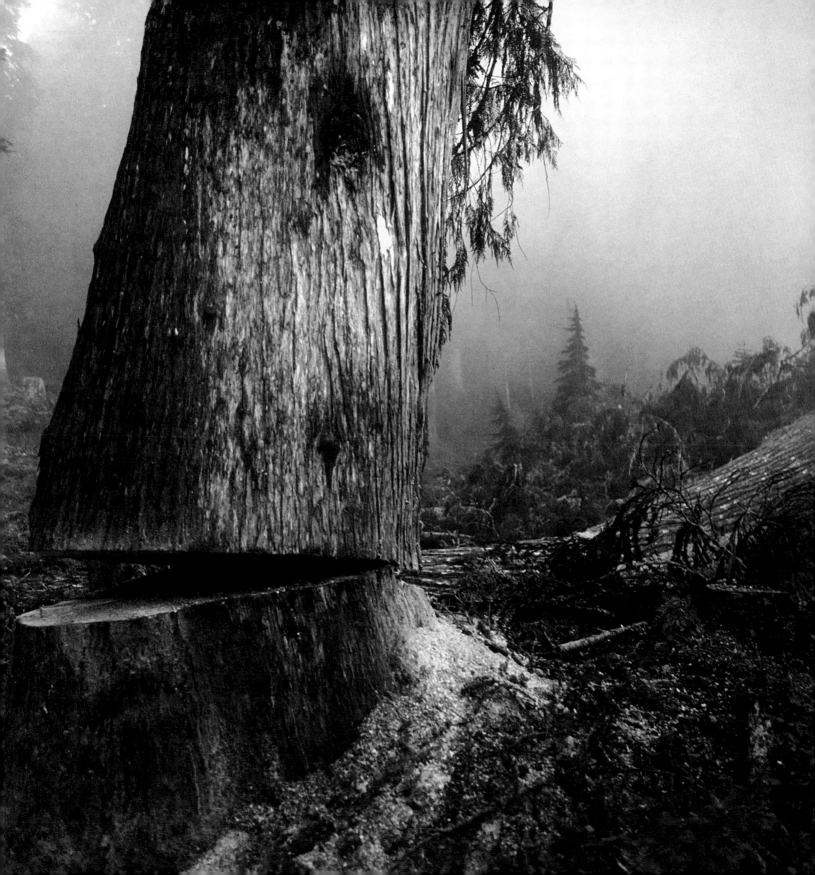

GUS FOSTER

born 1940

Cut Wheat

1988
Type-C print
18 x 86 ⅛ in.
Smithsonian
American Art
Museum,
Gift of the
Consolidated
Natural Gas
Company
Foundation

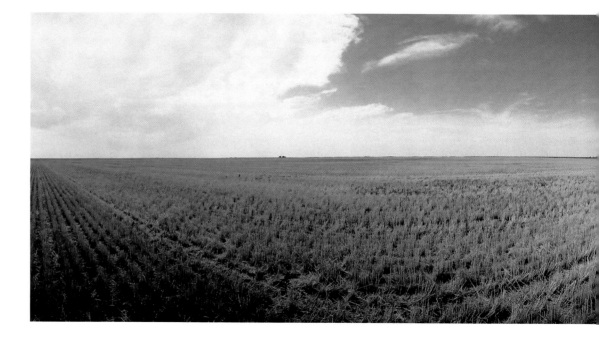

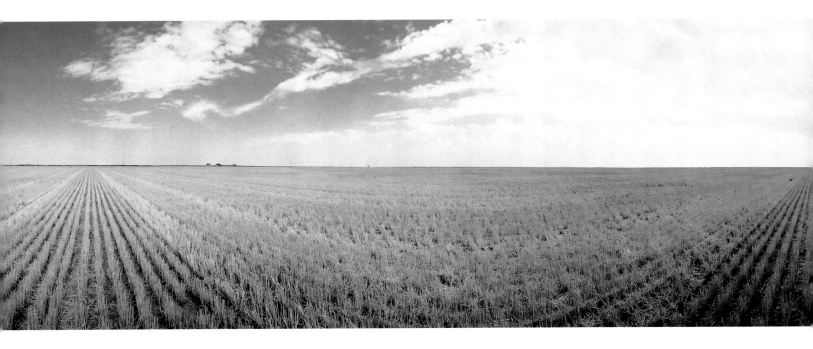

ROLAND L. FREEMAN

born 1936

Horse-drawn Cultivator. Mississippi, 1974

from the series *Southern Roads/City Pavements*

1974/printed 1982
gelatin silver print
11 ¼ x 13 ⅞ in.
Smithsonian
American Art
Museum,
Gift of George H.
Dalsheimer

The flat bottomland of Mississippi may lack the grandeur of some landscape locations, but Roland Freeman's photograph makes clear that it is crucial to the lives of those who farm it. The bold, triangular form of the horse-drawn plow, held upright solely by the soil in which it rests, gives this picture both its shape and its meaning. What is at issue is not the scenic value of farmland but its use value: still worked by horse-drawn implements, it speaks of traditional agricultural practices and of generations of small-scale Southern farmers who, as tenants or as owners of the land, eke out a living while maintaining preindustrial ways.

Freeman, an African American photographer interested in documenting his own cultural roots, took the photograph while working as a field researcher in folklore for the Smithsonian Institution. He also photographed for the Mississippi Folklife Project, taking pictures that show the surviving influence of African culture in the South. While his photographs are intended primarily as records of folkways, they also attain the formal and symbolic cohesiveness of works of art.

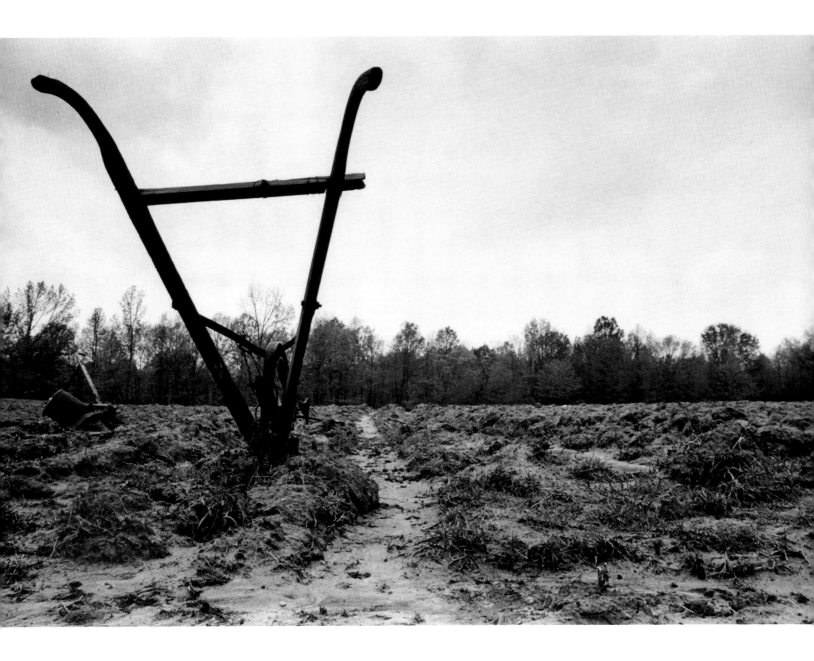

LAURA GILPIN

1891–1979

Pikes Peak and Colorado Springs

about 1926

platinum print

11 ⅞ x 9 ⅝ in.

Smithsonian
American Art
Museum, Gift of
Charles Isaacs and
Carol Nigro

Far above the overlapping profiles of foothills leading the eye up to Pike's Peak, a dark rain cloud lends an ominous note to this awe-inspiring vista. Just as important, the cloud serves as atmospheric camouflage for a formation of military airplanes. To Gilpin, a Colorado native and one of the few female landscape photographers of her era, the sight of such planes would still have been a novelty, since they became a part of modern warfare only a decade or so earlier.

Looked at today, however, Gilpin's photograph seems an anachronism. Delicately printed in platinum, a process used only by a small band of art photographers know as pictorialists, it surveys mountains, airplanes, and a barely discernible factory smokestack with equal and unruffled aplomb. Later photographers in the twentieth century would see the planes and smokestack as signs of the depredation of the great American West, and would take pains to show them as such. But in Gilpin's image there is only that tantalizing rain cloud to suggest that all is not perfect near the Garden of Eden.

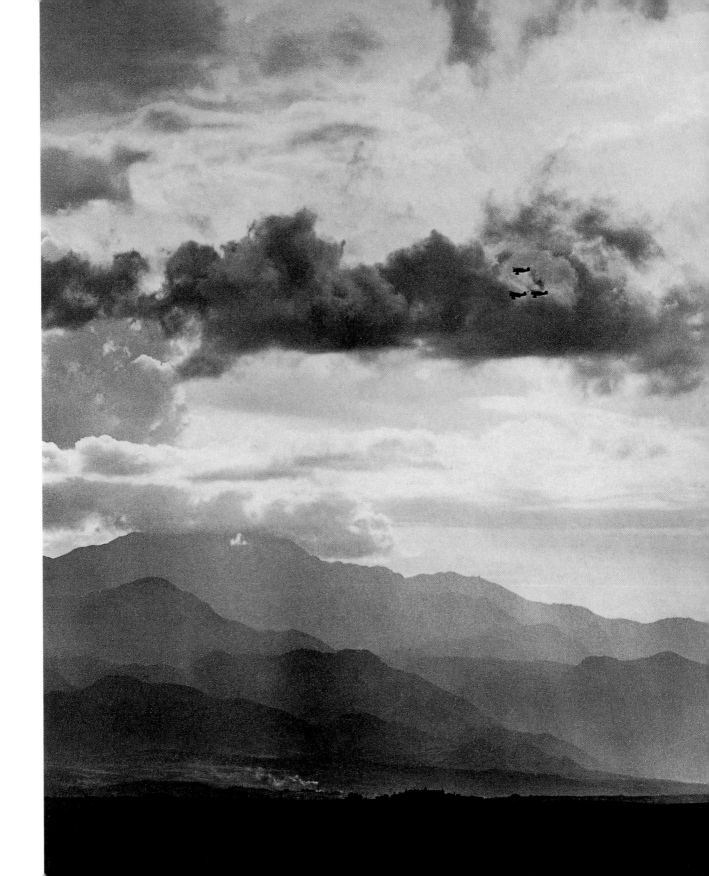

EMMET GOWIN

born 1941

Mount St. Helens, Washington

1980
gelatin silver print
9 ⅞ x 9 ¾ in.
Smithsonian
American Art
Museum, Transfer
from the National
Endowment
for the Arts

The fallen trunks of two uprooted trees form a perfect sight for contemplating the devastation wrought by the Mount St. Helens volcano, which had erupted only a few months before this picture was taken. Rather than functioning as photojournalism, though, Emmet Gowin's image invites sustained contemplation of nature's destructive side. The cracked, dried earth in the foreground and the steaming, broken cone in the distance create an atmosphere as desolate as a moonscape. Only the fallen tree trunks provide a clue that this view once was obscured by dense forest.

By invoking the style of pictures taken on the moon, Gowin effectively evokes the amazement and awe that astronauts felt when photographing the lunar landscape—and that nineteenth-century photographers felt when first surveying the American frontier. Gowin's interest in the landscape is more complicated than these precedents, however. In a career that began in the 1960s, he has largely concentrated on showing how human beings change the appearance of the natural world, for better or worse. Here, however, he recognizes that nature is quite capable of radically altering itself without any human assistance.

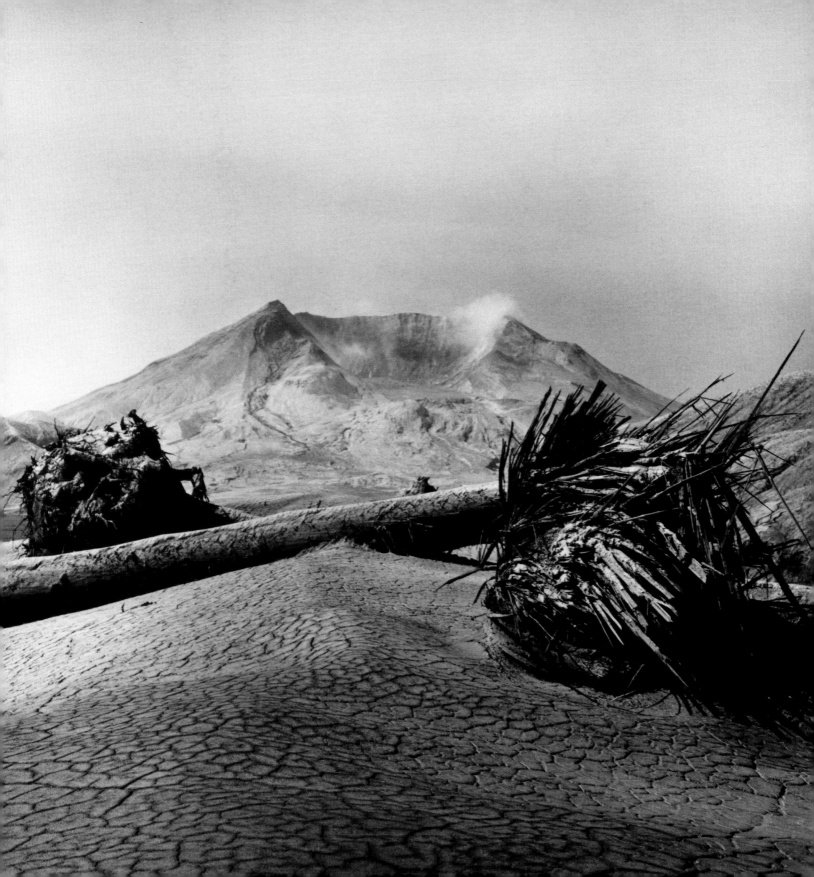

KAREN HALVERSON

born 1941

Hite Crossing, Lake Powell, Utah

1988
Ektacolor print
11 ½ x 23 in.
Smithsonian
American Art
Museum, Gift of the
Consolidated
Natural Gas
Company
Foundation

As a modern-day explorer in the American West, Halverson balances natural and man-made beauty. Working at dusk, she left her camera shutter open long enough to transform the waters of Lake Powell into a soft blue blur. In it are reflected the stark silhouettes of the surrounding cliffs, which are seen in more precise detail across the top of the photograph. The foreground is a surprise: the unexpected brightness of the sandstone shore comes from an artificial source: the headlights of the photographer's car.

The presence of artificial light in this otherwise simple scene is a reminder that the West is not the untouched or unspoiled place that has persisted in the popular imagination since the territory was first explored. Indeed, the lake itself is a construction of our own making, having been formed by the building of the Glen Canyon Dam in the 1950s. The apparently empty site where the photograph was made was once a thriving town where settlers could cross the Colorado by ferry; the town itself is now underneath the waters of Lake Powell—an irony the photographer makes clear by her choice of title.

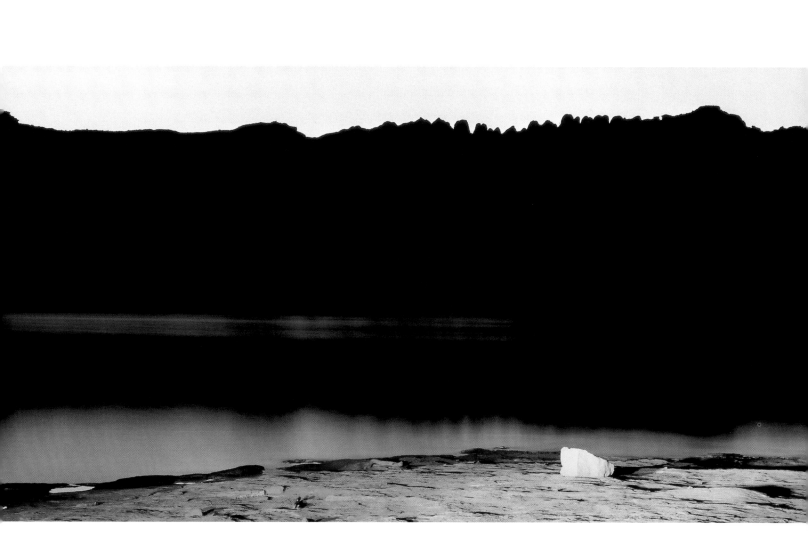

F. JAY HAYNES

1853–1921

Castle Geyser Cone, Yellowstone National Park

1884
albumen print
17 1/8 x 21 7/8 in.
Smithsonian
American Art
Museum, Gift of
Charles Isaacs

The existence of steaming, spouting geysers in the newly opened territories of the West enhanced the area's exotic appeal and attracted enough attention that by 1872 the thermal zone called Yellowstone was incorporated into the country's first national park. Few nineteenth-century Americans had seen anything like this caustic, belching, sulfuric vent before, and even today this straightforward landscape seems otherworldly because of its subject. The first photographers to take pictures of such geyser formations came as part of expeditionary survey parties, but later visitors like Frank Jay Haynes saw a commercial potential for their pictures.

Haynes was a studio photographer in the Dakota Territories until 1876, when he was hired by the Northern Pacific Railroad to take pictures along its route. As part of this work he visited Yellowstone Park and, after seeing its awe-inspiring natural features, decided to open a studio and gallery there. He later became the official park photographer, selling his prints to tourists. His efforts helped popularize the park both as a destination and as a symbol of the rugged beauty of the American landscape. His large, striking print of the Castle Geyser was intended for framing and hanging, and it proudly bears the artist's name and Fargo studio stamp in the lower right corner.

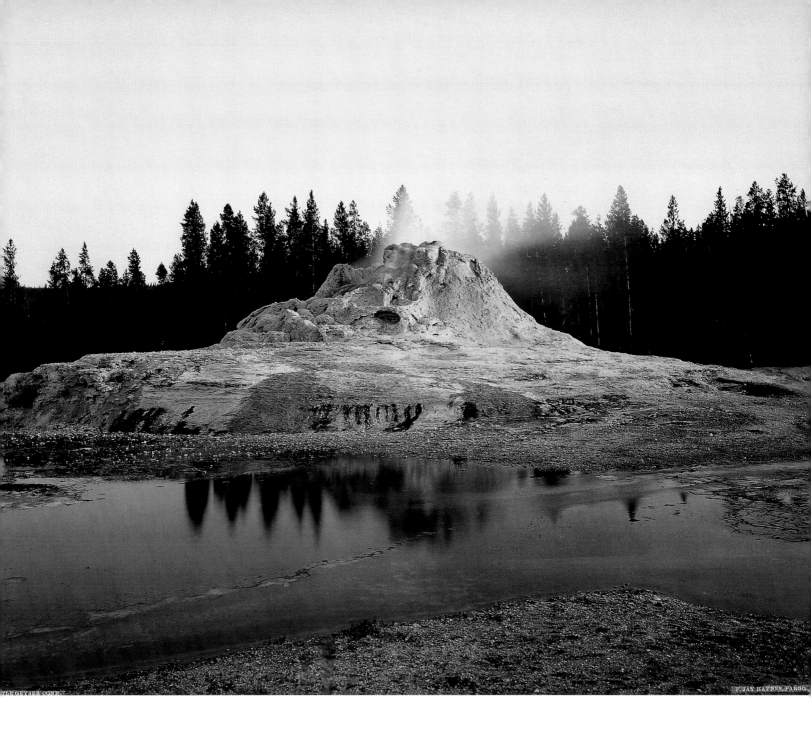

ALEX HESLER

1823 Canada–1895 USA

Falls of Minnehaha, Minnesota

about 1855
salted paper print
8 x 6 in.
Smithsonian
American Art
Museum,
Purchase from the
Charles Isaacs
Collection made
possible in part
by the Luisita L.
and Franz H.
Denghausen
Endowment

The blurred but viscerally discernible power of the cataract in the center of this oval scene suggests that the photographer was an adherent of the then-popular belief that nature was beautiful and inspiring to the degree that it was potentially dangerous. Surely anyone who happened to be swept over these falls would be smashed and drowned—at least that is what the poet Henry Wadsworth Longfellow imagined when he looked at this image in the nineteenth century.

Hesler had a daguerreotype studio in Chicago, where he displayed the first picture he made of the Minnehaha Falls; that daguerreotype was purchased and eventually given to Longfellow, who reportedly used it for inspiration in writing *The Song of Hiawatha*. When the picture became popular because of the poem, Hesler made copies using both the daguerreotype process and the newly introduced glass-plate negative. This particular image, an early example of a paper print made from a glass-plate negative, is probably a copy of a daguerreotype Hesler made earlier.

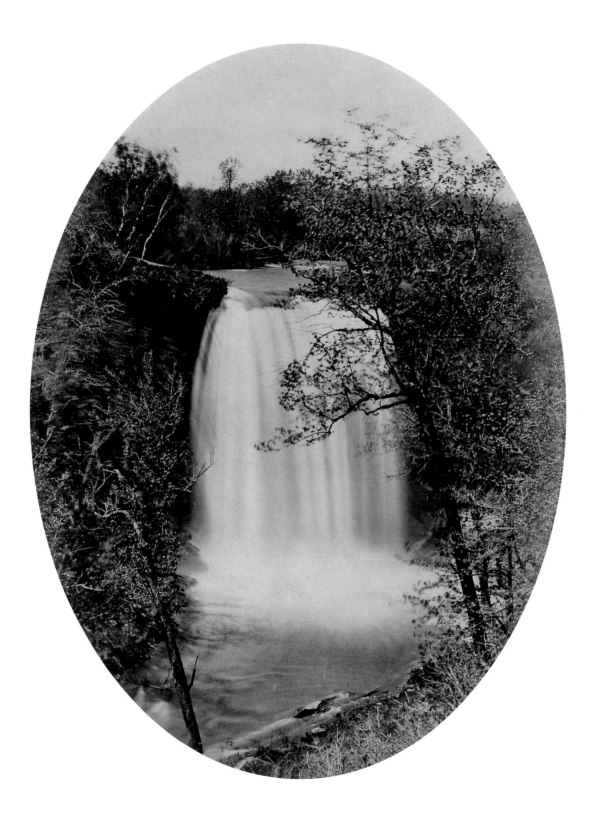

ALLEN HESS

born 1950

Oak Alley Plantation, River Road, Vacherie, Louisiana

1983/printed 1989
selenium-toned
contact print
7 ⅝ x 19 ½ in.
Smithsonian
American Art
Museum,
Gift of the
Consolidated
Natural Gas
Company
Foundation

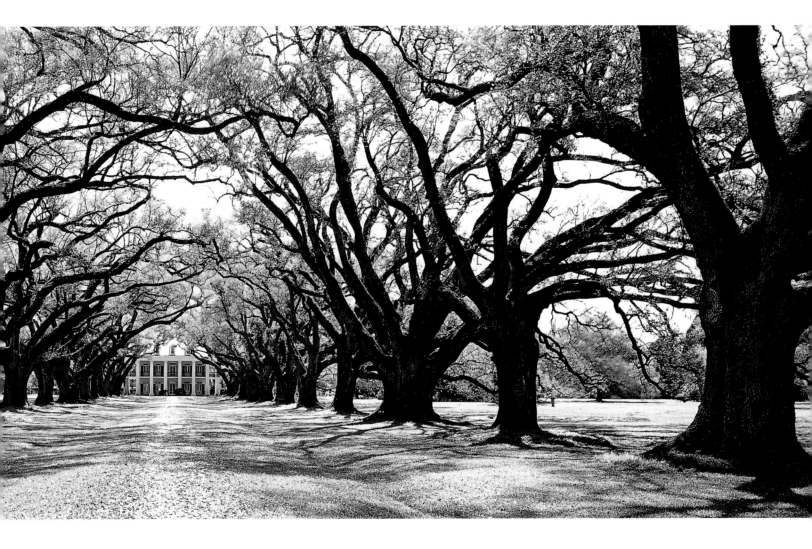

JOHN K. HILLERS

1843 Germany–1925 USA

Hopi Mesa

about 1872
albumen print
9 7/8 x 12 7/8 in.
Smithsonian
American Art
Museum,
Purchase from the
Charles Isaacs
Collection made
possible in part
by the Luisita L.
and Franz H.
Denghausen
Endowment

Although the subject here is a series of Hopi pueblos atop a mesa, the picture is organized like a traditional landscape: a foreground ledge provides a handy spot for looking off toward what could be a rocky peak in the distance. But the edges of the scene, which reveal an enormous plain below, belie this notion. It would be more accurate to call this picture a cityscape since the photograph, despite an air of desolation, is full of signs of life. These signs include houses, ladders for reaching them, drying fruit in the foreground, a literal chimney pot, a man standing in front of the house at center, and, on the right, a sleeping dog.

John K. Hillers, a Civil War veteran who had learned photography while serving as a boatman on an 1871 expedition down the Colorado River, took this picture while working for the Bureau of Ethnology, which was charged with collecting objects and images of Native American life. Hillers concentrated on the Hopi and Navajo, producing portraits as well as scenes of everyday domestic life. The mount of this albumen print, which features a decorative ink border, is uncharacteristic of ethnographic work and suggests that Hillers was also interested in having his photographs seen as works of art.

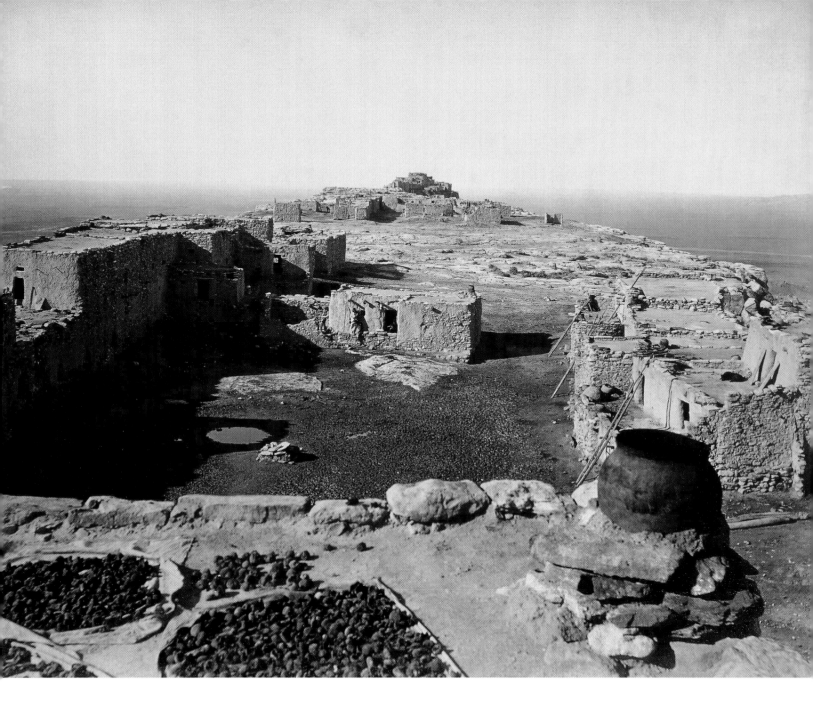

WILLIAM H. JACKSON

1843–1942

Grand Cañon of the Colorado

about 1880

albumen print

21 1/8 x 16 7/8 in.

Smithsonian

American Art

Museum,

Purchase from the

Charles Isaacs

Collection made

possible in part

by the Luisita L.

and Franz H.

Denghausen

Endowment

Jackson was the most prolific and long-lived photographer of the American West, working from 1870 well into the 1900s. He took this image of the West's most famous gorge about the time of a major juncture in his career, when he ended his decade-long association with a government survey team and opened a studio in Denver to sell his landscape pictures and stereo views directly to the public. This print, intended for display on a wall or in an album, is called mammoth-plate size, so named because the glass-plate negative from which it was printed was nearly two feet high. To take the picture Jackson had to carry the glass plate hundreds of miles without it breaking and brave setting up his camera and tripod on the edge of this precipice.

More than many photographs, Jackson's pictures are difficult to date because he printed and published them so often. Although this image bears the legend "W. H. Jackson & Co. Denver," the presence of two intrepid explorers at the image's center—one scouting the terrain through a telescope, one apparently relaxing—suggests that it may have been taken during Jackson's years with the U.S. Geological Survey. In any case, the composition demonstrates the influence of Jackson's friend Thomas Moran, the painter who traveled with Jackson during that survey. The strong dark form on the left effectively frames the canyon walls and receding river beyond it, creating a harmony on which few painters would feel obliged to improve.

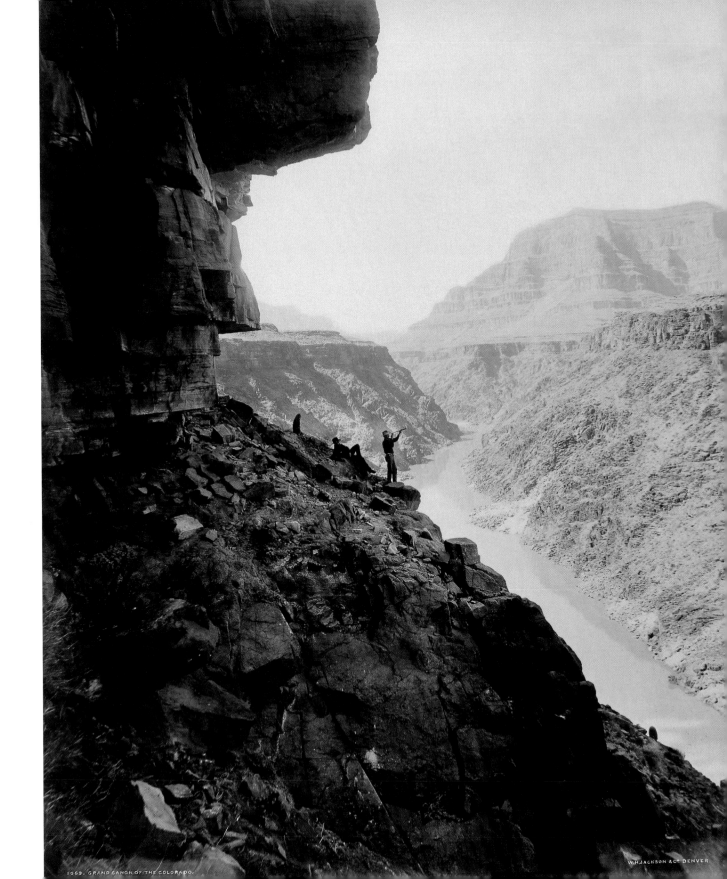

1069. GRAND CAÑON OF THE COLORADO.

W.H. JACKSON & C.º DENVER

ROBERT GLENN KETCHUM

born 1947

Things Have a Life of Their Own

from the series *Order from Chaos*

1982
Cibachrome print
29 7/8 x 37 3/4 in.
Smithsonian
American Art
Museum, Gift of an
anonymous donor

A visual thicket of tree trunks, limbs, and twigs runs from edge to edge in Ketchum's large color photograph, one of a series of pictures he calls *Order from Chaos*. While the idea of chaos is apparent in the image, its underlying order is more subtle. Partly it has to do with the picture's generally monochromatic, rusty coloration, which supplies an overall sense of unity. But a sense of order also is conveyed by the patterning of the hundreds of branches, which the camera lens has compressed so they seem to exist on a single, flattened plane.

Ketchum's interest in the landscape has less to do with such formal concerns than with his professed devotion to the beauty of the natural world. In this instance, the superficial disorganization of a deciduous forest conceals the organic, organized processes of nature, such as plant succession and stages of regrowth. By showing us the beauty of nature in a complex scene that defies the norms of the landscape tradition, Ketchum challenges the limits of our understanding of the natural world.

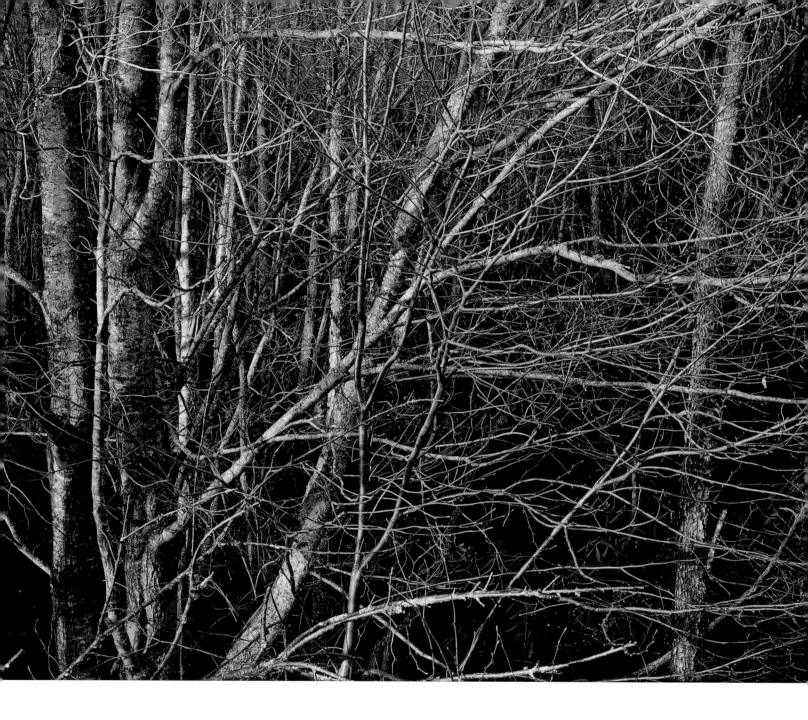

MARK KLETT

born 1952

Around Toroweap Point, just before and after sundown, beginning and ending with views used by J.K. Hillers, over 100 years ago

1986
gelatin silver print
19 7/8 x 16 in. each
Smithsonian
American Art
Museum, Gift of the
Consolidated
Natural Gas
Company
Foundation

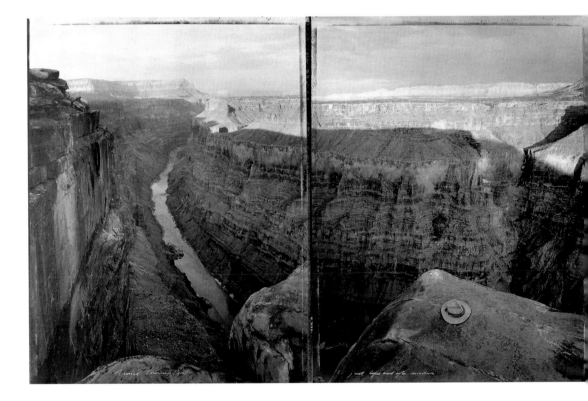

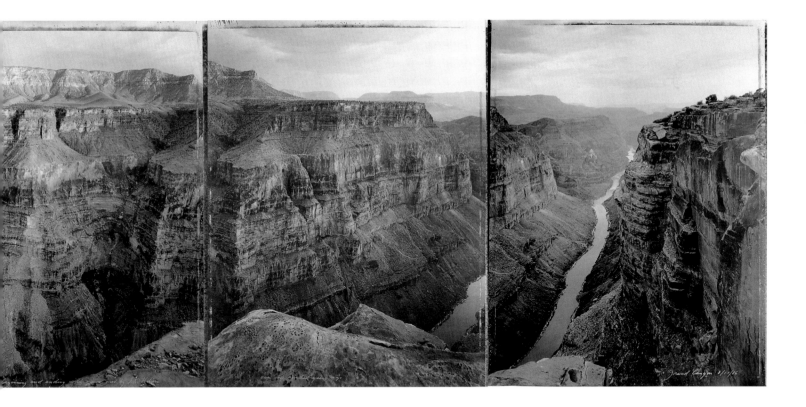

STUART KLIPPER

born 1941

Road to Bonneville Raceway, Great Salt Flats, Utah

from the series *The World in a Few States*

1990
Type-C print
12 x 38 in.
Smithsonian
American Art
Museum,
Gift of the
Consolidated
Natural Gas
Company
Foundation

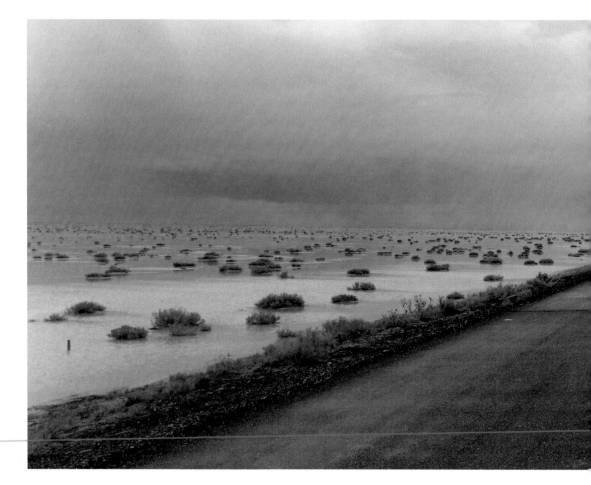

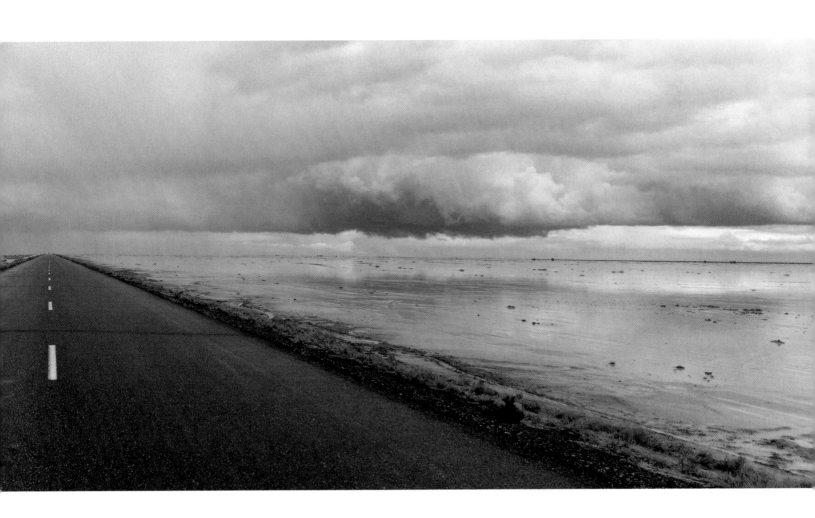

JOE MALONEY

born 1949

East Branch, Delaware River, New York

1979
Ektacolor print
12 ⅜ x 15 ⅝ in.
Smithsonian
American Art
Museum,
Gift of the
Consolidated
Natural Gas
Company
Foundation

Unlike the Hudson River, which inspired a famous "school" of landscape painters in the nineteenth century, the nearby Delaware River has been admired more for its trout than for its pictorial beauty. Joe Maloney has sought to rectify this situation in a photograph that makes the most of the subtlety of modern color film. The soft, shadowless light of an overcast day produces deeply saturated greens and yellows and a clear set of reflections on the water's surface. The same light, characteristic of a late fall or early spring day in the vicinity of New York's Catskill Mountains, where this picture is sited, seems to bleach the distant hillside and the bare tree limbs along the riverbank. The visual effect, paradoxically, is like a nineteenth-century painting, albeit without the Hudson River School painters' taste for exaggerated scale and meteorological drama. By eschewing theatricality and any sense of incident, Maloney produces a calm, intimate portrait of a place that seems ideally suited for solitude and meditation.

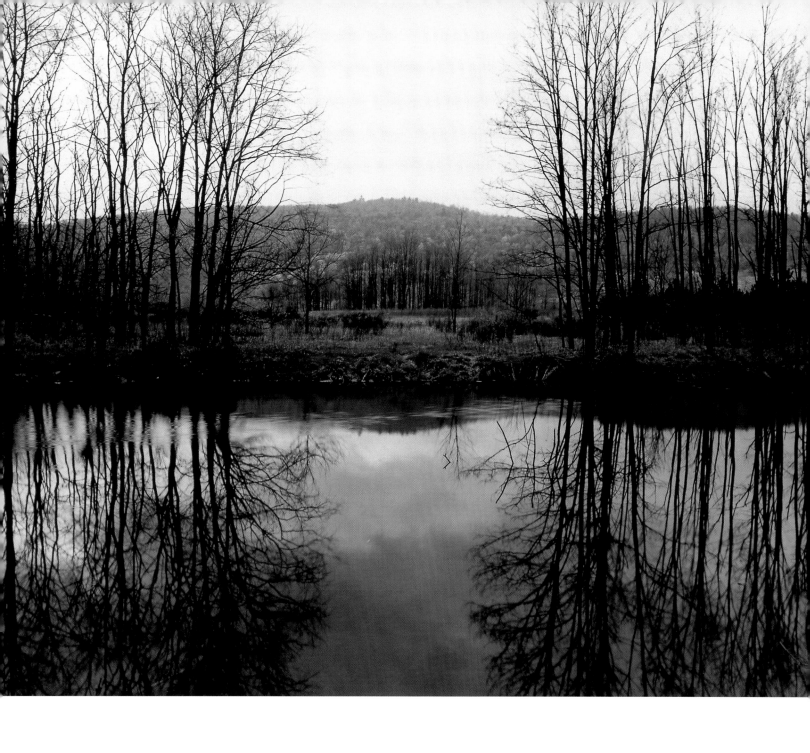

SALVATORE MANCINI

born Italy 1947

Petrified Forest, Arizona

1986
gelatin silver print
20 x 13 ¾ in.
Smithsonian
American Art
Museum,
Gift of the artist
in honor and
memory of
Aaron Siskind

Printed in extremes of black and white, Salvatore Mancini's view of a rock-strewn hillside centers on an upthrust finger of stone that pierces the dark sky as well as the picture's top edge. Near the opposite, bottom edge, a petroglyph harking back to the region's ancient Anasazi civilization delivers an inscrutable message. Mancini has dedicated the picture to Aaron Siskind, his photography teacher and a photographer known for his preference for abstract forms, many of them derived from graffiti. Fortuitously, the picture also recalls the work of Ansel Adams, whose 1923 picture *The Arrowhead, Yosemite,* also features an upthrust rock reaching into a darkened sky. But where Adams's similar Yosemite image speaks to nature's unchallenged power, Mancini's photograph reminds us of the inevitability of change. Not only have the people who left the petroglyph message long vanished, but also many of the rocks in the area were once trees that have been transformed by geological pressures—a so-called petrified forest.

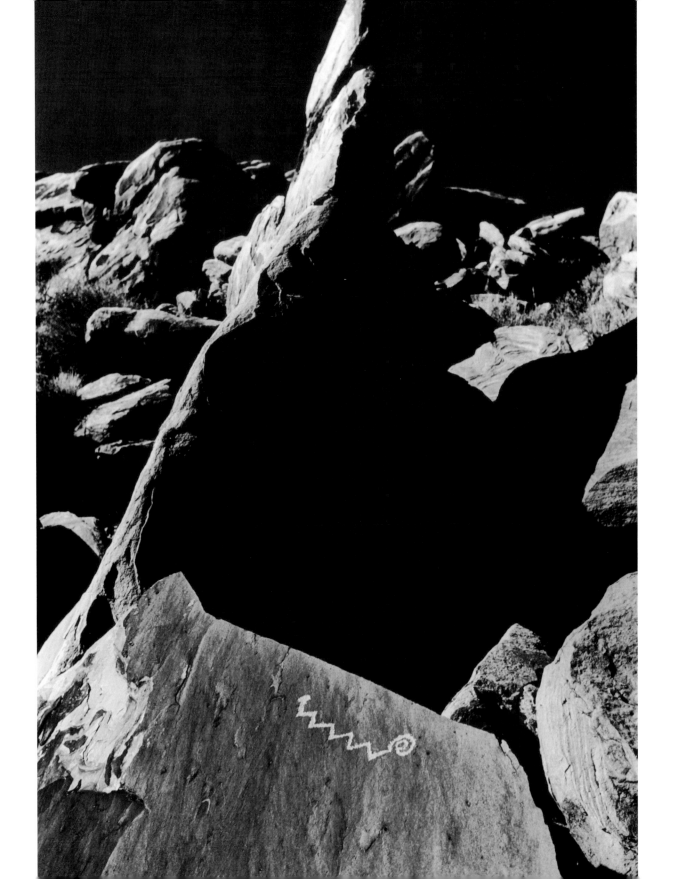

SKEET McAULEY

born 1951

Alaska Pipeline

1990/printed 1991
Fujichrome print
mounted on
Plexiglas
27 ¾ x 86 in.
Smithsonian
American Art
Museum,
Gift of the
Consolidated
Natural Gas
Company
Foundation

RICHARD MISRACH

born 1949

Hawaii IV

from the portfolio *Hawaii*

1978/printed 1980
dye transfer print
15 ⅛ x 18 ⅛ in.
Smithsonian
American Art
Museum, Gift of
Joshua P. Smith

An unruly profusion of the green leaves and brown trunks of Hawaiian palm trees makes Richard Misrach's photograph seem chaotic, if not unintelligible. Three faint blue streaks in the center of the image add to the mystery. The comforting sense of depth recession and pictorial organization normally found in landscape images is missing; instead, the visual stimulus is flattened and diffused. The effect is similar to that of Jackson Pollock's famous "drip" paintings, which defied conventions of formal organization and control at the time they were made.

Misrach's point, however, is not solely formal. He does not merely mean to show that Pollock's gestural, spontaneous method can be applied to photographs. By setting up his camera in the thick of the palms, he suggests that nature is not necessarily organized and arranged to produce an ordinary sense of beauty. Yet the overall composition he has discovered has a beauty that is "extra"-ordinary. By using the camera without the prejudice of preconceived ideas, he reveals a different side of nature, one in which complexity, density, and impenetrability are virtues, not defects.

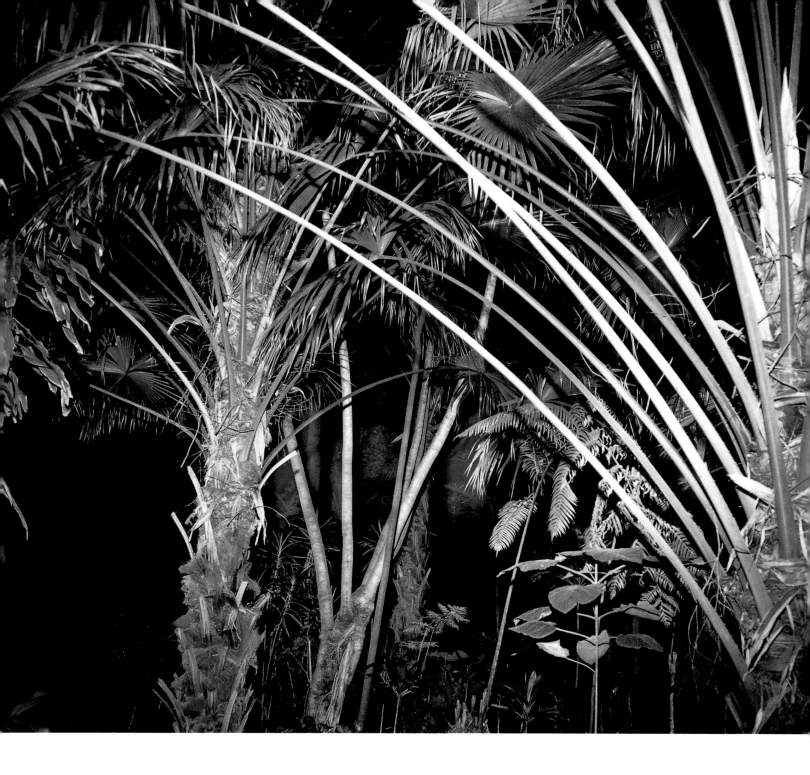

RAY MORTENSON

born 1944

Amtrak, Hudson Generating Station, Jersey City and Manhattan from Laurel Hill

1982

gelatin silver print

24 7/8 x 31 7/8 in.

Smithsonian
American Art
Museum,
Gift of the
Consolidated
Natural Gas
Company
Foundation

Neat horizontal divisions of railroad tracks, dirt road, and horizon line cannot disguise the scarred state of the land in this view of the New Jersey Meadowlands, just to the west of New York City. Mortenson's picture departs from most landscapes because it is urban rather than arcadian and because its beauty resides in the manner in which the photograph was made, rather than in the subject itself. Still, it is possible to imagine how this place might once have been beautiful, with its rocks, trees, and waterways, before the demands of metropolitan life reshaped it.

To make a silk purse out of a visual sow's ear, Mortenson chose a camera and lens that could render the scene with precision and sharpness from foreground to background. By using black-and-white film he reduced the myriad of shapes and structures to their essentials. The alignment of the tracks and road with the bottom edge of the frame gives the picture a stable base, and the curve of the road on the left is repeated in the arc of the river farther off on the right. These formal, organizational aspects give the landscape its coherence, but its interest lies mainly in the complexity of human enterprise that it encompasses. Besides the railroad, one can see a power plant, excavated hills, containment dams, storage tanks, single-family homes, and, above the horizon, the pale gray skyline of Manhattan. Since the picture was taken, that skyline, with the World Trade Center towers most prominent, has become both poignant and nostalgic.

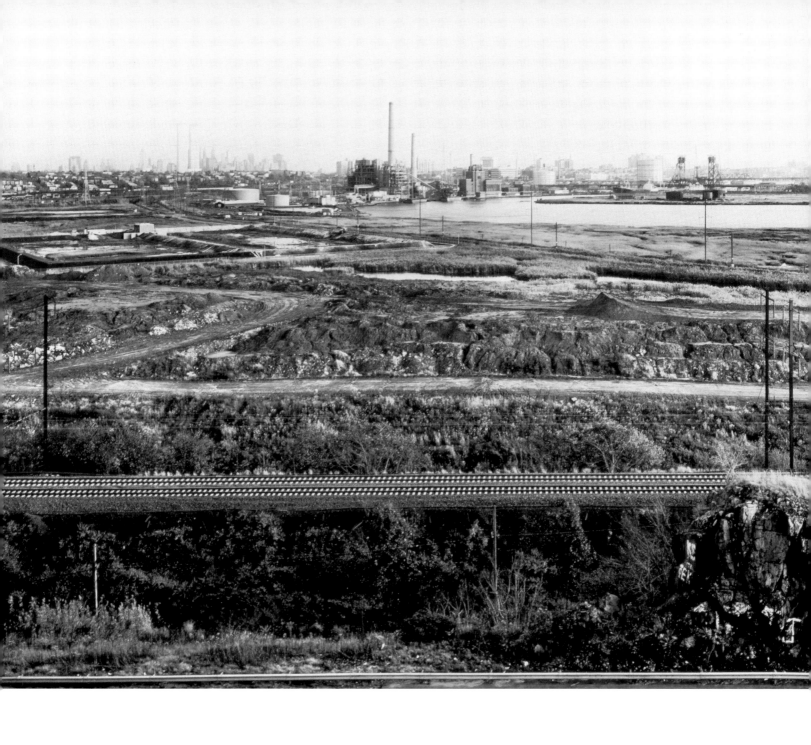

EADWEARD MUYBRIDGE

1830 England–1904 England

Valley of the Yosemite from Union Point

1872

albumen print

17 x 21 ½ in.

Smithsonian
American Art
Museum,
Gift of Dr. and Mrs.
Charles T. Isaacs

A rugged spire of rock in the foreground of Muybridge's view of Yosemite Valley gives his picture a spectacular sense of vertigo that, in the nineteenth century, made it all the more appealing to audiences already entranced by the region's scenic wonders. One wonders, first of all, where the photographer stood to achieve such a precipitous point of view. In fact, Muybridge was renowned for his exploits in lugging his heavy camera in search of dramatic compositions; reportedly his porters refused to accompany him to many of the perilous viewpoints he found. Here the climb was definitely worth the trouble, since it allowed him to contrast the tonally dark rock of the foreground with the pale valley beyond, which is lighter because of intervening haze—what is known to artists as aerial perspective.

Muybridge was an Englishman who came to San Francisco and, seeing the opportunities there, opened a photography business in 1867. Although Charles L. Weed and Carleton Watkins already had made virtuoso photographs in Yosemite, Muybridge soon gained fame for the beauty of his views, which he sold both as large, mammoth-plate prints and as stereo views. Ironically, his fame as a landscapist caused him to be hired by California Governor Leland Stanford, who asked him to find a way to photograph a trotting horse in stop motion. Muybridge did, with the result that he gave up his career in landscape photography to pursue making sequential studies of what he called "human and animal locomotion"—now-legendary images that are forerunners of motion pictures.

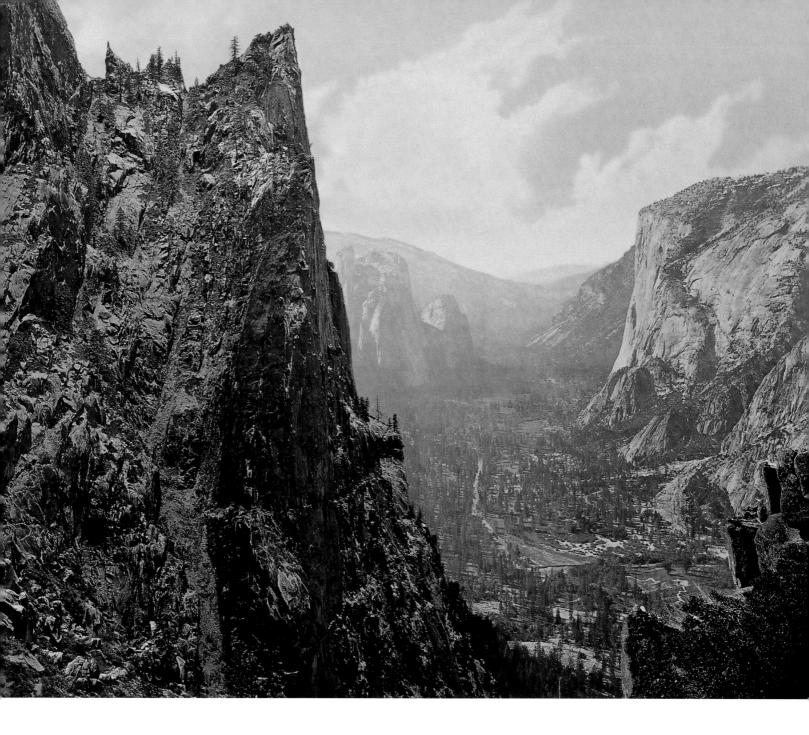

TIMOTHY H. O'SULLIVAN

1840 Ireland–1882 USA

Cañon de Chelle, Walls of the Grand Cañon about 1200 Feet in Height

from the Wheeler Survey

1873
albumen print
8 x 10 ⅞ in.
Smithsonian
American Art
Museum,
Purchase from the
Charles Isaacs
Collection made
possible in part
by the Luisita L.
and Franz H.
Denghausen
Endowment

This view is deservedly one of the best-known nineteenth-century landscapes of the American West. Less stark and forbidding than much of the photography produced by government-sponsored expeditionary surveys after the Civil War, the scene practically invites the viewer into its space by giving the eye a clear, central course to follow from the foreground into the distance. As a result, one can imagine traveling on the trail into the canyon and even stopping to camp out in the tents pitched beside the trail on the valley floor. Left of the tents is a rude lean-to made of branches and earth, evidence that the photographer's party was not the first to visit the place. Three tall spires on the right stand like sentinels overlooking the scene, as if ensuring its eternal tranquility.

O'Sullivan made this landscape while attached to the Wheeler Expedition, which was exploring lands west of the hundredth meridian, a line of longitude that divides the continent roughly in half. Lt. George Wheeler, a member of the Army Corps of Engineers, was interested in part in showing that the West was ripe for settlement. But this region, at least, already had been settled: another O'Sullivan picture, taken farther into the valley, shows the famed Cañon de Chelle cliffside dwellings, remnants of an earlier and equally enterprising civilization.

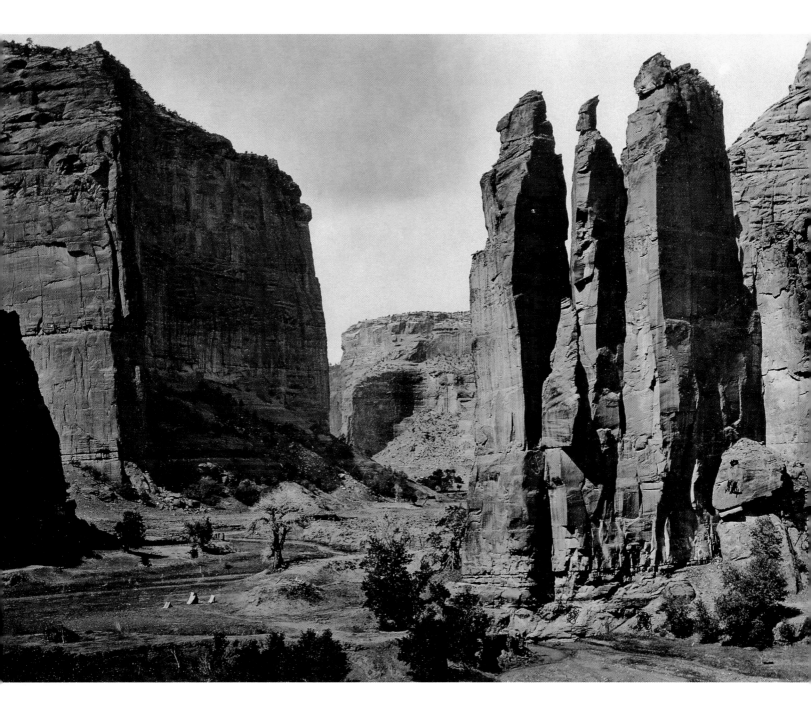

TIMOTHY H. O'SULLIVAN

1840 Ireland–1882 USA

Quarters of Men in Fort Sedgwick, Known as Fort Hell

1865
albumen print
7 ⅝ x 10 in.
Smithsonian
American Art
Museum,
Purchase from the
Charles Isaacs
Collection made
possible in part
by the Luisita L.
and Franz H.
Denghausen
Endowment

Two men in what appear to be white lab coats inspect a scene that surely ranks as an exemplary landscape of destruction. Under a top layer of bare earth is a network of entrenchments, channels, and tunnels propped up with logs and rough boards to approximate the look of a town of streets and houses. O'Sullivan, one of the most esteemed Civil War photographers, has found the fort abandoned but intact, a relic of the siege of Petersburg, Virginia, a nearly yearlong standoff that led to the Confederate Army's surrender.

Such empty, barren scenes as this are common in photographs of the Civil War, since photographers and their equipment usually arrived on the battlefield after hostilities ceased and the dead and wounded were removed. Also, the photographic materials of the day were too slow to capture action, so actual combat pictures were impossible. Yet the sense of the intensity of the conflict—the world's first instance of "total warfare"—is readily apparent in the landscape. The nearly complete elimination of any natural topography speaks metaphorically to the derangement of life suffered by the Union soldiers who built and lived in this warren of dirt. Incongruously, a blasted bare tree stands over the desolation, the only thing brave enough—or foolish enough— to rise above the horizon line during the siege.

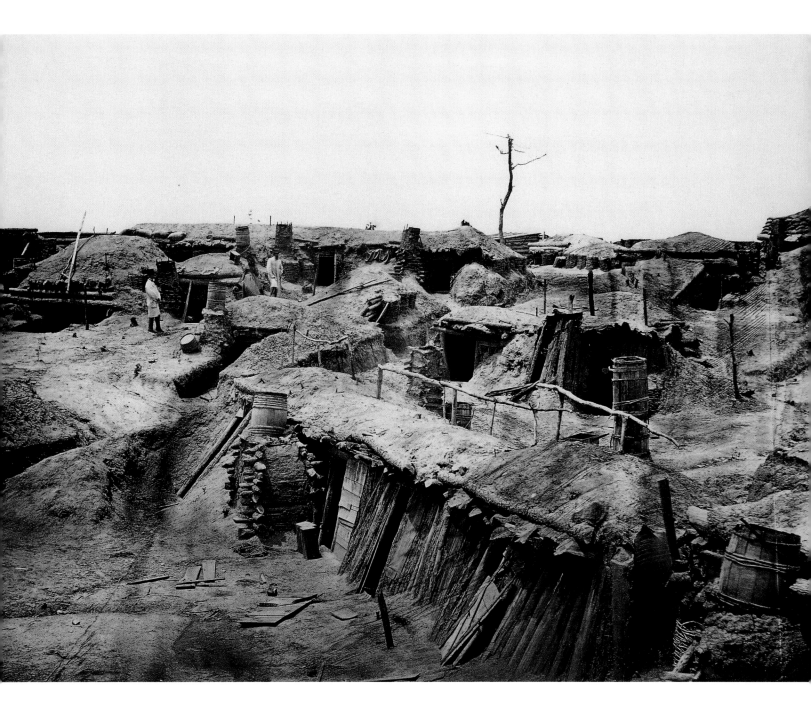

TIMOTHY H. O'SULLIVAN

1840 Ireland–1882 USA

Tufa Domes, Pyramid Lake, Nevada

from the King Survey

1867

albumen print

7 7/8 x 10 5/8 in.

Smithsonian

American Art

Museum,

Purchase from the

Charles Isaacs

Collection made

possible in part

by the Luisita L.

and Franz H.

Denghausen

Endowment

Looming above the surface like marooned modern sculpture, the tufa domes of Pyramid Lake provide the sole visual interest in this photograph from the first government-commissioned survey of the West. Such domes are formed from minerals dissolved in the bubbling gases that escape from vents in the lakebed. In the distance beyond them lie mountains high enough to be covered in snow, although the picture's spectral surface gives the impression of searing heat. The number "91," appearing on the light-colored dome closest to the camera, is not part of the scene but was etched into the glass-plate negative as a way of cataloguing the picture for later identification. The clouds also were likely added later, since light-sensitive emulsions at the time did not allow photographers to record ground and sky in a single exposure. The scratches and wavy stains surely were inadvertent but are signs of the difficulty of making photographs so far from civilization.

O'Sullivan took this picture fresh from the Civil War, where he had witnessed firsthand the horrible results of several battles, and some observers believe that this traumatic experience accounts for the stark, inhospitable quality of his early landscapes of the West. Others have pointed to the influence of Clarence King, the leader of the expedition for which O'Sullivan was the official photographer. King was convinced that the world had been formed in a series of violent upheavals, or "catastrophes," and he saw evidence for this theory in the landforms he found between the Rocky Mountains and the Sierra Nevada.

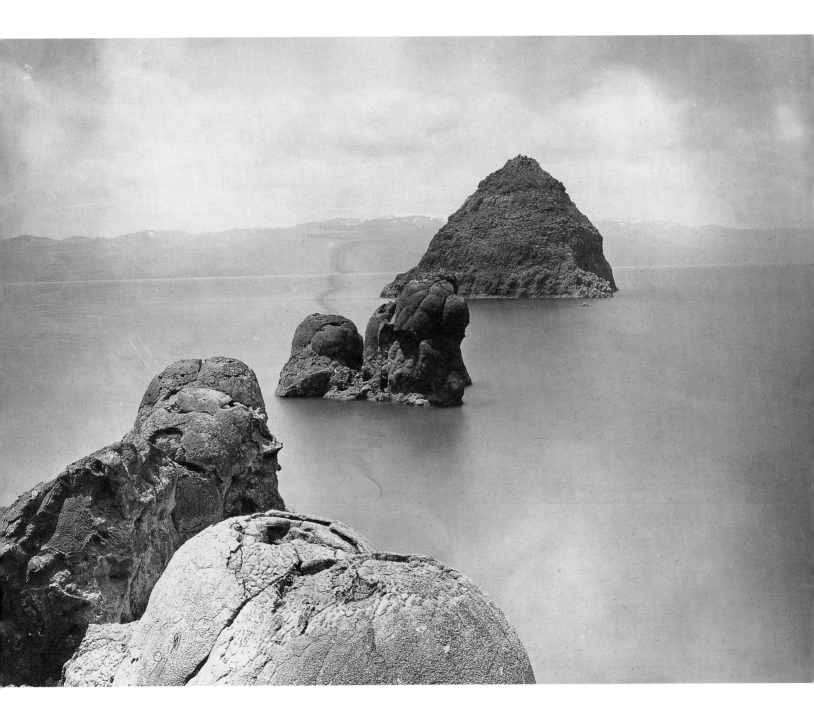

JOHN PFAHL
born 1939

Niagara Power Project, Niagara Falls, New York
from the series *Power Places*

1981
Ektacolor Plus print
16 x 20 in.
Smithsonian
American Art
Museum,
Gift of the
Consolidated
Natural Gas
Company
Foundation

A cliff of dynamited rock and a regiment of electric towers lined up like soldiers on a parade ground overshadow the fabled pictorial allure of Niagara in John Pfahl's descriptive color photograph. Seemingly far from the sublime power of the falls, which has attracted artists and photographers since the nineteenth century, Pfahl's river is only a dark band at the bottom of a picture otherwise devoted to evidence of human efforts to harness its energy. Still, the photographer has admitted a sense of the grandness of the place by using the vocabulary of the picturesque in his composition, including a rosy light that bathes the scene in soft, warm tones.

Pfahl was one of the first photographers to turn his attention from depicting the natural landscape to poking fun at the conventions of the landscape genre itself. He took this picture in the same year that his book *Altered Landscapes* appeared. In his photographs for that book he added his own props to the scene to contravene normal depth recession or to mimic elements in the picture. (In one photograph, of automobile tires holding down a tarp, he added doughnuts to the foreground.) Behind the humor, though, lies a serious intent. Pfahl shows us a world that is still beautiful, but that beauty is no longer entirely nature's own.

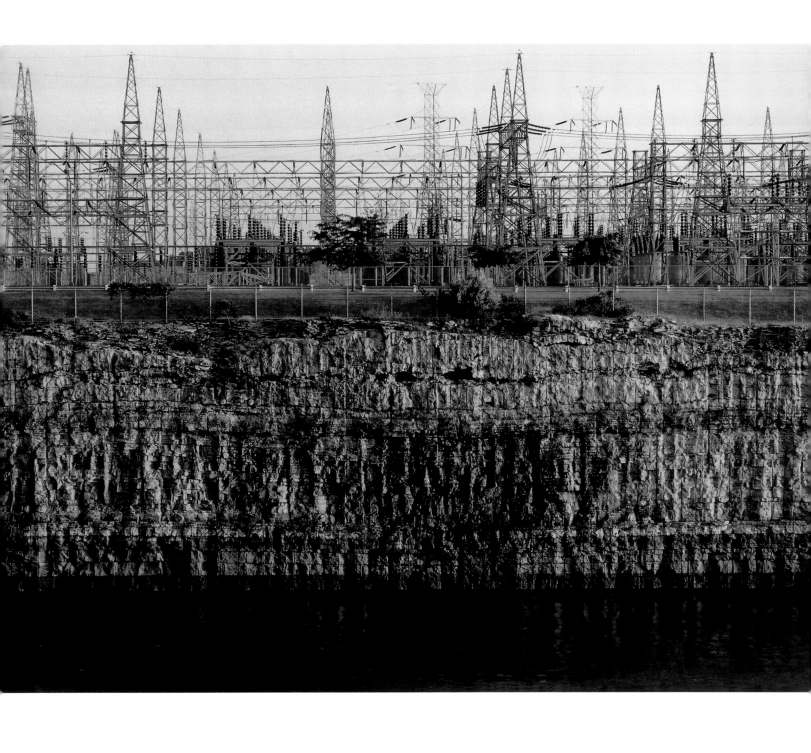

WILLIAM H. RAU

1855–1920

Cathedral Rocks, Susquehanna River near Meghoppen
for the Lehigh Valley Railroad

1899
albumen print
17 ¼ x 20 ⅜ in.
Smithsonian
American Art
Museum,
Gift of Dr. and Mrs.
Charles T. Isaacs

At the turn of the century, when steam ruled the rails and automobiles were in their infancy, Americans could think romantically about railroads and railroad travel. That, at least, was the idea of the Lehigh Valley Railroad, which tried to promote tourism by hiring Rau to take photographs along its routes in rural Pennsylvania and New York. Rau combines the conventions of Western landscape photography with those of Eastern scenic painting to produce an inviting vista in which the twin railroad tracks and a double row of utility poles are evidence of both modernity and human settlement. (The newer set of poles may support telephone wires, since the telephone was then on the verge of replacing the telegraph.)

Accenting the scene is a man in the middle distance, standing between the rails. To the right across the river, a canoe or rowboat is pulled up on shore. The connection between man and vessel is unclear, as is the identity of the object on which the man appears to lean (a cane? umbrella?), but there is no mistaking his confidence and poise. Without him the craggy cliffs and disappearing tracks might seem desolate and uninviting, the exact opposite of the theme that the photographer was hired to portray.

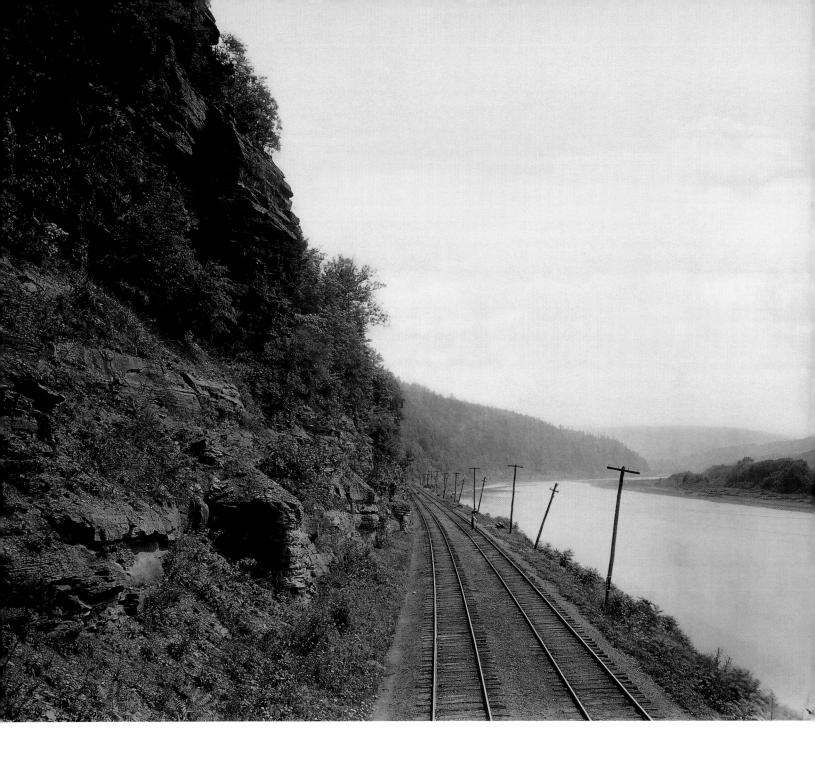

LARRY W. SCHWARM

born 1944

Flint Hills Prairie Fire near Cassoday, Kansas

1990
Ektacolor print
13 ¼ x 13 ¼ in.
Smithsonian
American Art
Museum,
Gift of the artist

A line of flames on a flat horizon creates a visual display of somber beauty in Schwarm's photograph, in which color plays a defining role. The foreground is a dark black, rising to red near the flames, then yellow and orange from the smoke, and finally a glimpse of blue sky before blackness returns at the top. The simplicity of the composition belies the inherent complexity of the subject, which is the tallgrass prairie of middle Kansas. Like many ecosystems, prairie benefits from being swept occasionally by fire; most likely the line of fire seen here was purposely set by biologists in an effort to keep the prairie healthy.

To present-day travelers whisking by on interstate highways, the Great Plains can seem a featureless region devoid of the spectacle of great mountains or gorges. But as Schwarm, a Kansas native, has recognized, there is a special beauty to be found in the stacked geometry of earth and sky. Luckily, modern color films are capable of recording the subtleties of light and atmosphere on which such beauty often depends.

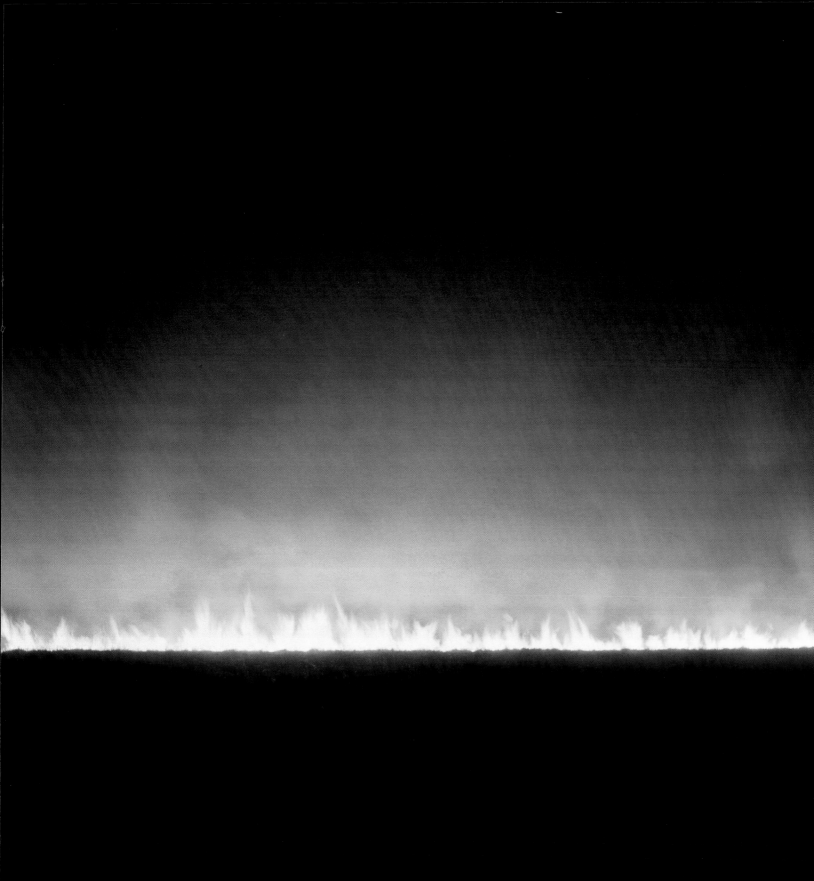

AARON SISKIND

1903–1991

The Tree, Martha's Vineyard

1973
gelatin silver print
10 ⅜ x 10 ⅜ in.
Smithsonian
American Art
Museum,
Transfer from
the National
Endowment
for the Arts

Photography is commonly thought to be a medium of description, but this does not deny that it is capable of abstract passages and meanings. What is most striking about this tree, for example, is the way in which its pale branches reach out like twisted arms from its darker, shaded limbs and trunk. The effect is not only anthropomorphic but also graphically tortuous, rendering the surrounding setting almost superfluous. It is impossible to tell where exactly the tree is, how high it might be, or what it looks like from a distance; all that matters is the strange calligraphy of its branches.

Siskind is the most persuasive abstract photographer of the second half of the twentieth century. When he took this picture he already had spent twenty years making close-up photographs of tar strips, defaced signs, and crumbling walls. Those images generally eliminate all sense of context and depth, creating rough equivalents of the abstract expressionist painting of the time. Here, Siskind increased his level of difficulty by including more context and by focusing on a natural subject in a landscape setting. What links this image to his other abstract work is its implication of human activity, evident in the partly healed but still raw scars of the pruning saw.

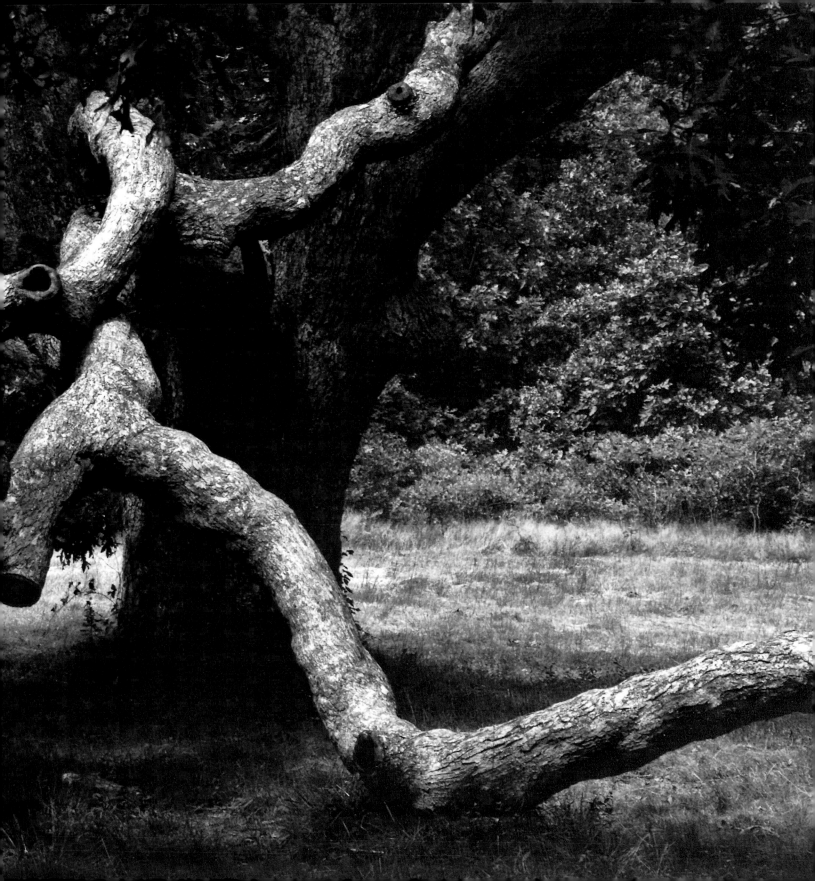

TERRY TOEDTEMEIER

born 1947

Burning Railroad Tie, Burlington Cut near Catherine Creek, Klickitat County, Washington

1987/printed 1988
selenium-toned
gelatin silver print
8 ⅝ x 18 ½ in.
Smithsonian
American Art
Museum,
Gift of the artist

This image is a late-twentieth-century iteration of a renowned nineteenth-century subject, the railroad along the path of the Columbia River between Oregon and Washington. What distinguishes Toedtemeier's version is its uncanny sense of incident: a smoking railroad tie that seems to have ignited for no apparent reason and, on the opposite side of the photograph, the hulking shadow of a stone monolith cast onto the side of its close neighbor. Such surrealistic effects went unrecognized or unappreciated one hundred years earlier.

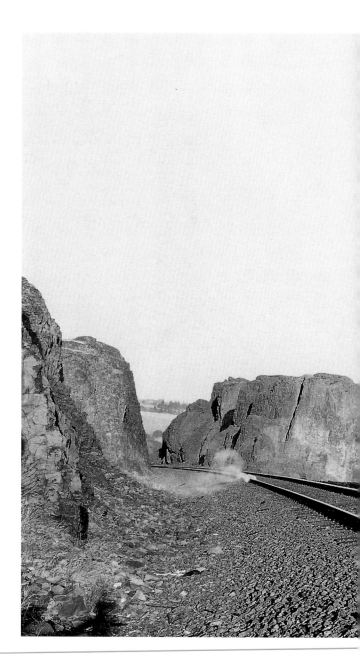

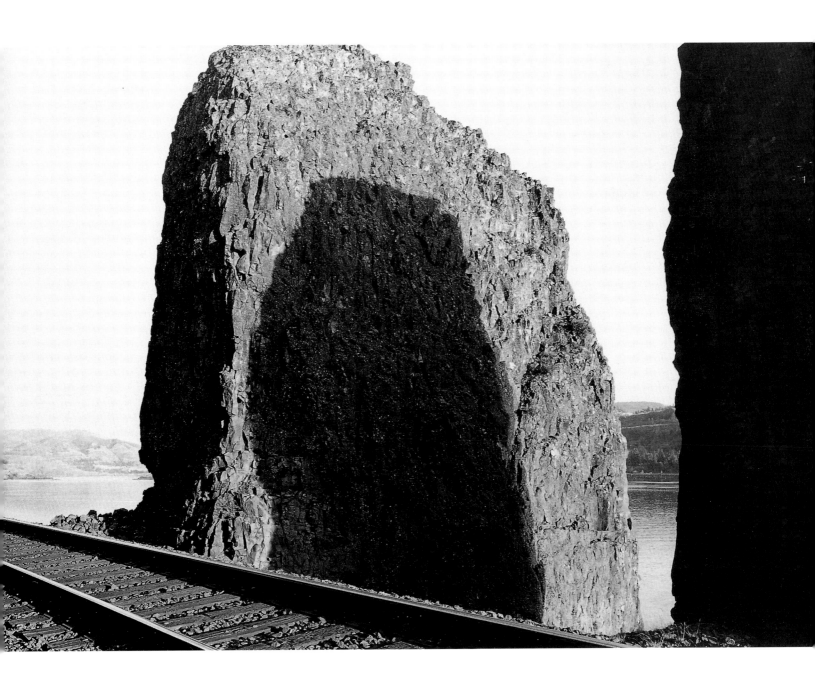

DORIS ULMANN

1882–1934

Corn Shocks and Sky

about 1925

platinum print

7 ¼ x 6 in.

Smithsonian
American Art
Museum,
Gift of Dr. and Mrs.
Charles T. Isaacs

With its arched top and small size, this print is almost like a greeting card, but Ulmann surely intended it as a work of art. Its simplicity of form is its strongest suit; three quarters of the image is a cloud-filled sky, one quarter is a dark hillside topped by a rank of tied corn shocks. The arrangement of the shocks on the land is just barely discernible in the original print, which Ulmann made using the platinum process beloved by early-twentieth-century photographers who subscribed to the soft-focus, impressionistic style known as pictorialism.

Ulmann was a pictorialist who operated a portrait studio in New York City, where her clients presumably enjoyed the effects of a fuzzy focus. Beginning in the 1920s she made annual summer trips to the Appalachian Mountains where, using the same style, she attempted to document mountain ways and mountain people. The results are less anthropology than subjective folklore, since her eye could not resist scenes with pictorialist aesthetic possibilities. But as this picture suggests, in some situations the cold, clear gaze of modern photography is not necessarily the best approach to a given subject.

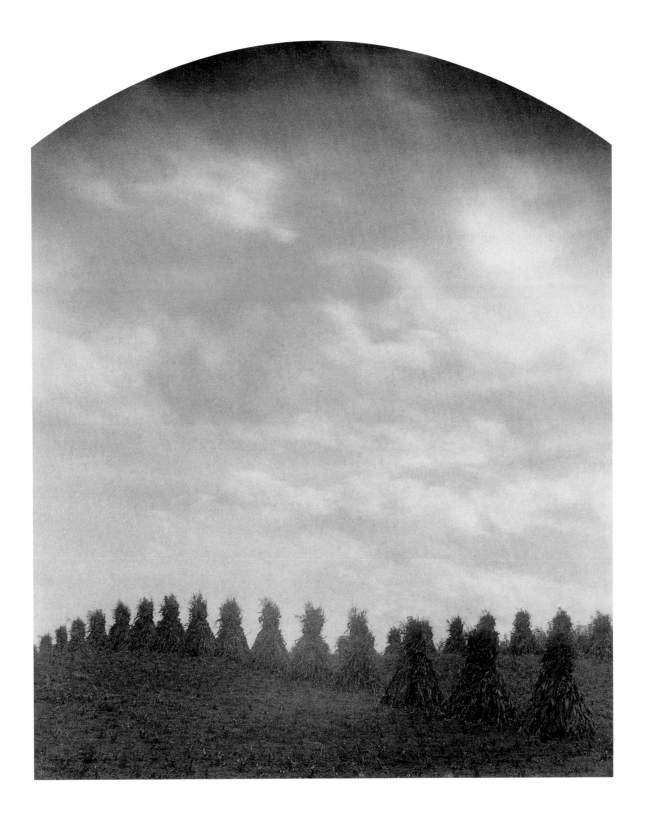

UNIDENTIFIED ARTIST

active nineteenth century

Echo Lake, North Conway, Franconia, White Mountains

about 1870

albumen print

8 ¼ x 6 ½ in.

Smithsonian

American Art

Museum,

Purchase from the

Charles Isaacs

Collection made

possible in part

by the Luisita L.

and Franz H.

Denghausen

Endowment

With its image of a rock face split down the middle and flipped 180 degrees like a playing card, this picture has the quality of an optical illusion. Only the blurred quality of the image's lower half and a smidgen of shoreline at the bottom edge give evidence that the cliff is reflected in the appropriately named Echo Lake. Whoever took the photograph had a sophisticated eye for landscape composition, but it is also likely that the unnamed artist had seen pictures of this scene beforehand. The White Mountains of New Hampshire were America's most popular tourist destination for much of the nineteenth century, as well as a prime site for painters interested in landscapes of American terrain. Photographers took advantage of the region's rugged scenery from the 1840s on. The visual echo of Echo Lake was widely recorded and reproduced as part of a commercial trade in images that showed the beauty of wild, untouched areas of the United States.

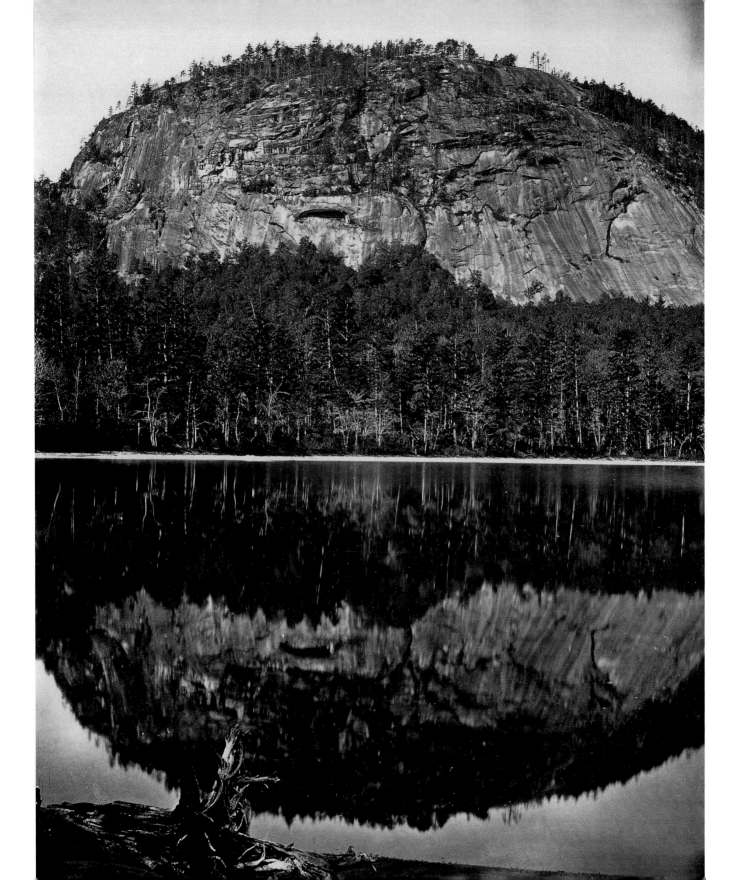

UNIDENTIFIED ARTIST

active nineteenth century

Harlem River

about 1875

albumen print

10 1/8 x 13 3/4 in.

Smithsonian
American Art
Museum,
Purchase from the
Charles Isaacs
Collection made
possible in part
by the Luisita L.
and Franz H.
Denghausen
Endowment

The pastoral beauty of this watery scene resides mainly in the foreground, where tidal flats and salt grass merge softly with their reflections in the river. Beyond them, on the thin line that forms the horizon, a different story is told. Dwellings, sheds, and a bell tower dot the land, and on the right are moored side-wheel steamships and ferryboats. In the middle of the water is a barge that announces itself with a sign that reads "Vineyard Bathing Beach." The view encompasses what was then the northern reaches of New York City, where the Harlem River splits from the East River and crosses over to the Hudson, separating Manhattan Island from the Bronx.

The image is printed on albumen paper, which means it was made well before the turn of the century, when gelatin-silver printing became the rule. The picture also can be roughly dated by judging the state of settlement: until the third quarter of the nineteenth century, northern Manhattan consisted mainly of farmland and forest. The photographer who chose this scene left an ambiguous message: are viewers meant to admire the extent to which New York is filling in its natural geographic boundaries, or to gaze longingly at traces of undisturbed nature soon to be supplanted by the growth of urban life?

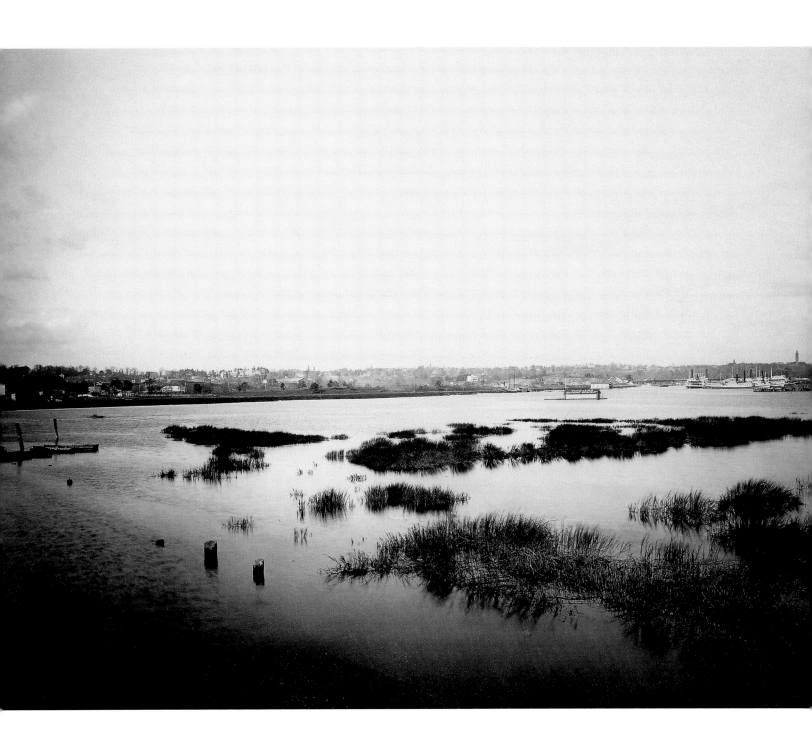

ADAM CLARK VROMAN

1856–1916

Around Zuni, from Northeast of Pueblo "99"

1899
platinum print
6 ½ x 8 ½ in.
Smithsonian
American Art
Museum,
Purchase from the
Charles Isaacs
Collection made
possible in part
by the Luisita L.
and Franz H.
Denghausen
Endowment

To a turn-of-the-century viewer, this cloud-laced landscape of the American Southwest would have been a novelty. Before the development of modern films, photographers had to use black-and-white emulsions that were overly sensitive to blue light. As a result, most nineteenth-century landscape photographs have bald skies; those that do not invariably were printed from two negatives, one exposed for the ground and one for the sky. But Vroman's orthochromatic ("correct color") picture is all of a piece, with no evidence of manipulation.

Vroman, who lived in southern California, photographed extensively in Arizona and New Mexico between 1895 and 1904, concentrating on the Navajo and Hopi peoples and recording their rituals and pueblo dwellings. This picture, which features an adobe structure and wooden corral in the foreground and large mesas in the distance, was made during a government-sponsored survey of pueblos. Vroman turned his camera 180 degrees from the pueblo in which he was standing to show not only evidence of animal husbandry but also the grand view that the pueblo's residents enjoyed on a daily basis.

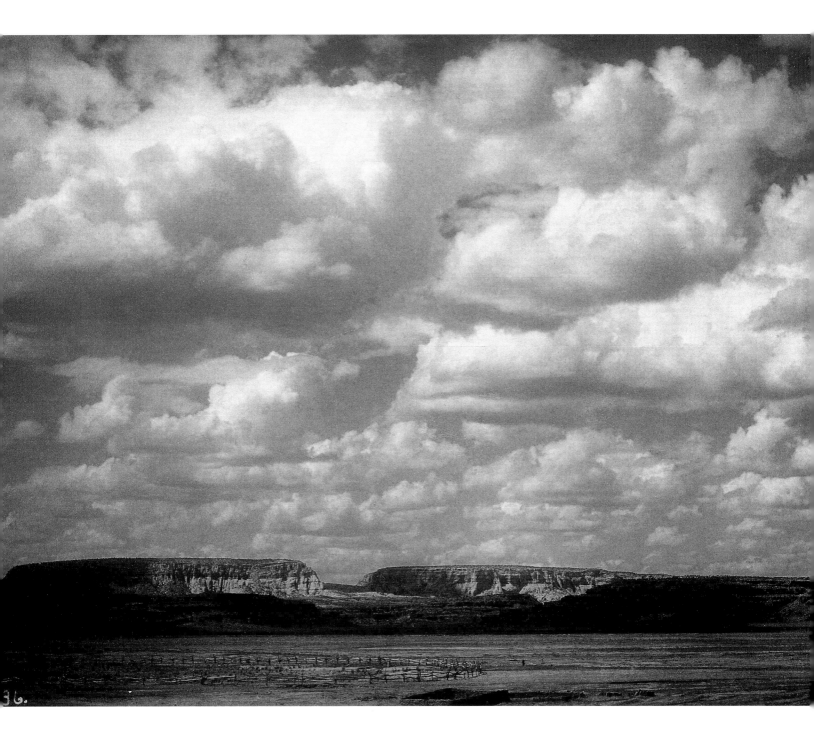

CARLETON E. WATKINS

1829–1916

The Three Brothers, Yosemite

about 1865/
printed after 1875
albumen print
12 ½ x 8 ⅛ in.
Smithsonian
American Art
Museum,
Purchase from the
Charles Isaacs
Collection made
possible in part
by the Luisita L.
and Franz H.
Denghausen
Endowment

The "Three Brothers"—a nickname for three knobby peaks that loom above Yosemite Valley—are almost white apparitions in the distance of Watkins's landscape, yet in reflection they are curiously vivid. The secret of this visual conundrum is not darkroom trickery but science: distant objects are seen through layers of atmosphere that diffuse their appearance, whereas close-up objects like the lake's surface do not suffer the same fate. In any case, Watkins has carefully framed the picture to give equal billing to the reflection and its source, and artfully counterbalanced the peaks on the left with three tall trees on the right.

Watkins was the second photographer to venture to Yosemite to take views of its dramatic scenery, making the first of several trips there in 1861. His pictures proved so popular across the country that the federal government acted to preserve the region, creating the germ of the national park system we know today. The popularity of views of Yosemite also ensured Watkins's financial success; in 1865 he opened a gallery in San Francisco that sold prints of his negatives. The economic depression of 1875 left him bankrupt, however, and his negatives were taken over by the firm of Isaiah Taber, which is why the inscription "Taber Photo, San Francisco," and not Watkins's name, appears at the bottom of this print.

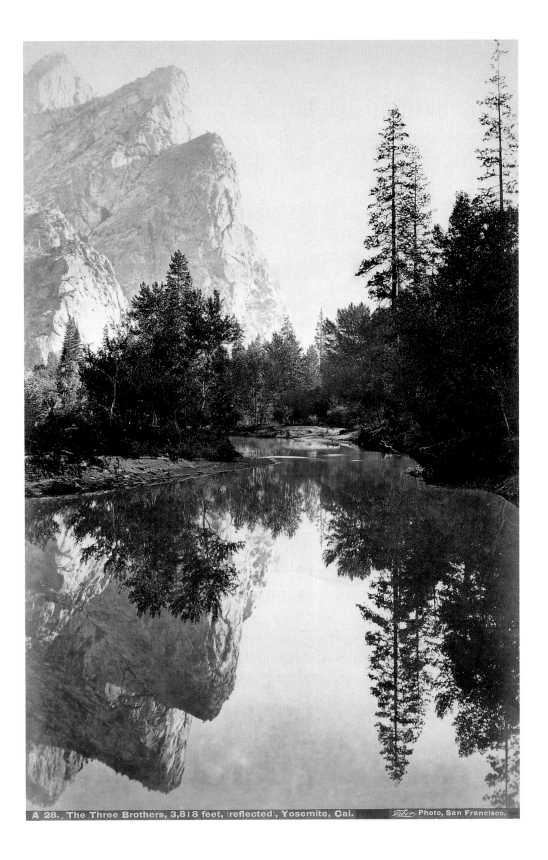

A 28. The Three Brothers, 3,818 feet, (reflected), Yosemite, Cal. *Taber* Photo, San Francisco.

CHARLES L. WEED

1824–1903

Mirror Lake and Reflections, Yosemite Valley, Mariposa County, California

1865
albumen print
15 ½ x 20 ¼ in.
Smithsonian
American Art
Museum,
Gift of Dr. and Mrs.
Charles T. Isaacs

Like Carleton Watkins, his main competitor, Weed recognized the pictorial dividend to be gained by showing Yosemite's glorious geological features in duplicate, using the valley's lakes as reflecting ponds. In all other respects his composition is that of a classical landscape painting, with a near subject (a dead tree branch) pointing out over the middle ground toward the high mountains in the distance. The result is picturesque, in the sense that the viewer is invited comfortably into the scene. Nature is arrayed in front of the camera so serenely that the majesty of the surrounding mountains is downplayed.

Weed first traveled to what was then known as "Yo-Semite," in 1859, but with a relatively small camera; he returned in 1865 with a larger model capable of using what were called mammoth plates. Compared to other photographers of Yosemite, he apparently felt no need to emphasize how sublime the place was. But the growth of a commercial market for Yosemite views led to competition, which in turn led photographers to increase the feeling of visual drama in their pictures. Weed did not establish a salesroom of his own but sold his prints through the gallery of Thomas Houseworth in San Francisco, which is the name affixed to the mount of this beautiful print.

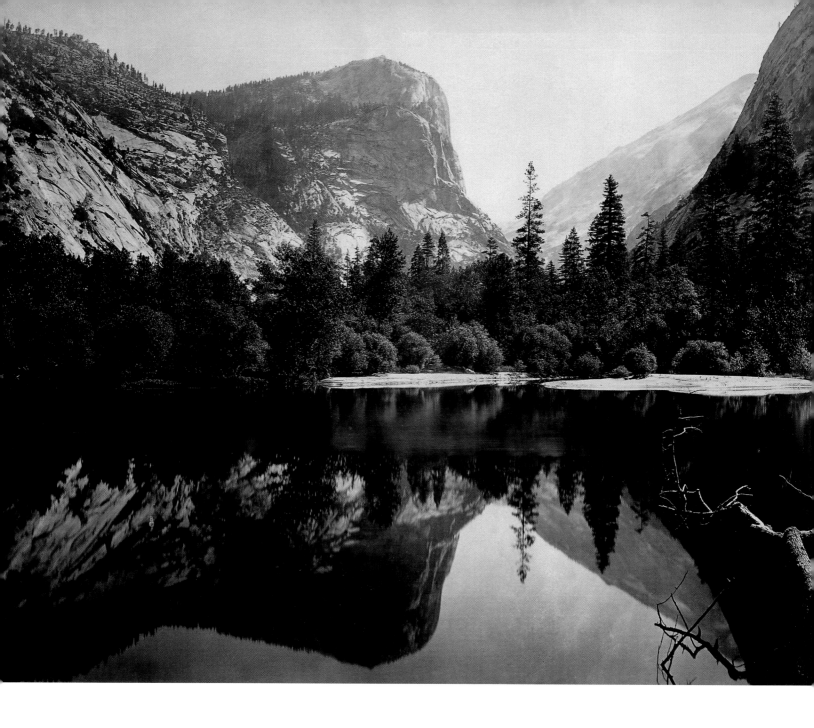

BRETT WESTON

1911–1993

Swamp

1947
gelatin silver print
7 ¾ x 9 ⅝ in.
Smithsonian
American Art
Museum, Gift of
Joshua P. Smith

As the son of the modernist photographer Edward Weston, and as a committed modern photographer himself, Brett Weston was never interested in description for its own sake. Rather, he sought to use his camera to transform reality into visual forms and patterns that could be appreciated on their own. Certainly that is what he accomplished here, since the dark forms of the nearest cedar tree trunks merge with their reflections to create a series of rhythmic vertical lines across the image. The floating lilies and other aquatic plants in the foreground appear to be on the same visual plane as the reflected trees in the distance. As a result, the picture defines space in a way that defies the perspective of ordinary vision.

In addition, Weston has used the materials of conventional landscape photography to produce something else: an abstraction that is not far removed from the aspirations of contemporaneous American painters such as Adolph Gottlieb, Robert Motherwell, and Jackson Pollock. That a precisely rendered, crisply printed picture of nature can produce the sensation of abstraction is one of the paradoxes of photography, and perhaps the central issue that preoccupied American photographers for most of the twentieth century.

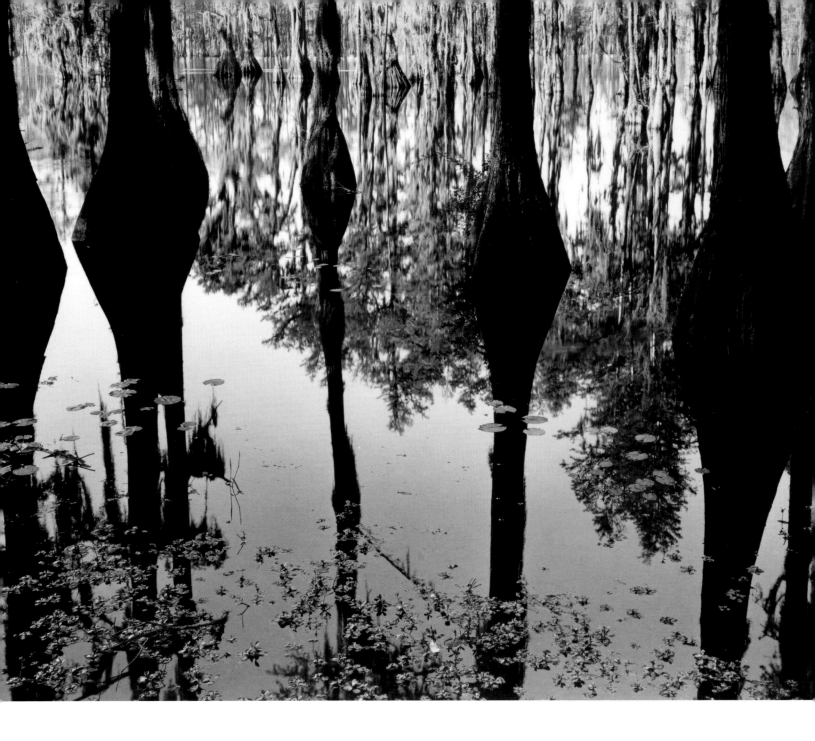

Index of Titles

Sources

p. 8: Ansel Adams, *An Autobiography* (Boston: Little, Brown and Co., 1985), 76

p. 54: Letter in Minnesota Historical Society from Alex Hesler to Russell Blakeley (P1127.–1.); cited in Anne H. Blegen, "Minnehaha Falls and Longfellow's 'Hiawatha,'" *Minnesota History* 8, no. 3 (September 1927): 281–82

p. 78: Eadweard Muybridge, *The Human Figure in Motion* (London: Chapman & Hall, 1901)